table of Contents

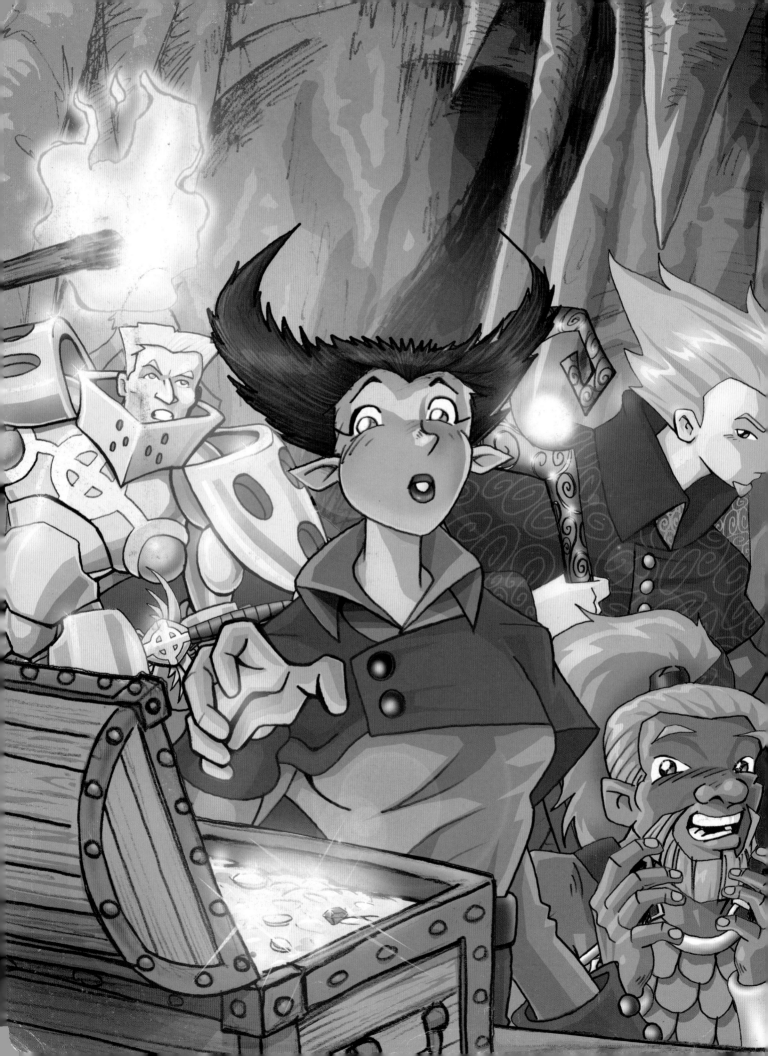

David Okum

IMPACT

CINCINNATI, OHIO

www.impact-books.com

About the Author

David Okum has worked as a freelance artist and illustrator since 1984. He has had comic book work published since 1992 when he had a story published in a *Ninja High School* anthology by Antarctic Press. He has since been included in two other Antarctic Press anthologies and several small press comic books. His writing and artwork have appeared in six role-playing books by Guardians of Order. He is also the author and illustrator of *Manga Madness, Superhero Madness* and *Manga Monster Madness* from Impact Books.

David studied fine art and history at the University of Waterloo in Ontario and works as a high school art teacher. Somehow he has turned his overactive imagination and doodles into a career.

Dedication

This book is dedicated to my mother, who never gave me a hard time for daydreaming.

Metric Conversion Chart

To convert	to	multiply by
Inches	Centimeters	2.54
Centimeters	Inches	0.4
Feet	Centimeters	30.5
Centimeters	Feet	0.03
Yards	Meters	0.9
Meters	Yards	1.1
Sq. Inches	Sq. Centimeters	6.45
Sq. Centimeters	Sq. Inches	0.16
Sq. Feet	Sq. Meters	0.09
Sq. Meters	Sq. Feet	10.8

Edited by Christina Xenos
Designed by Wendy Dunning
Production art by Amy Wilkin
Production coordinated by Matt Wagner

Acknowledgments

I'd like to thank the following people for their help and contributions in putting this book together:

Jennifer, Stephanie and Caitlin Okum, for their support and understanding as each book gets bigger and bigger.

My editors: Christina and Pamela and designer: Wendy for making my work look good.

My good friends over the years who helped me define this vision of a Fantasy Setting, most specifically Nick Rintche, Mitch Krajewski, Stephen Markan, Rich Kinchlea, Dave Kinchlea, Arek Skibicki, John Okum, Vlad Kinastowski, Les Aiken, Peter Cornish, Rob Reinhart, Tim Macneil, James Nicoll, Craig Emick, Joe Gallipeau and the many others who have helped who I have forgotten to include in this list. You know who you are.

fw F+W PUBLICATIONS, INC.

Other fine Impact Books are available from your local bookstore, art supply store or direct from the publisher. Visit their website: <http://www.impact-books.com>

10 09 08 07 06 5 4 3 2 1

DISTRIBUTED IN CANADA BY FRASER DIRECT
100 Armstrong Avenue
Georgetown, ON, Canada L7G 5S4
Tel: (905) 877-4411

DISTRIBUTED IN THE U.K. AND EUROPE BY DAVID & CHARLES
Brunel House, Newton Abbot, Devon, TQ12 4PU, England
Tel: (+44) 1626 323200, Fax: (+44) 1626 323319
Email: mail@davidandcharles.co.uk

DISTRIBUTED IN AUSTRALIA BY CAPRICORN LINK
P.O. Box 704, S. Windsor NSW, 2756 Australia
Tel: (02) 4577-3555

Library of Congress Cataloging in Publication Data
Okum, David
 Manga fantasy madness / David Okum.– 1st ed.
 p. cm.
 Includes index.
 ISBN-13: 978-1-58180-708-0 (alk. paper)
 ISBN-10: 1-58180-708-2
1. Fantasy in art—Juvenile literature. 2. Comic books, strips, etc.—Japan—Technique—Juvenile literature. 3. Cartooning—Technique—Juvenile literature. I. Title.
NC1764.8.F37O48 2006
741.5—c22 2005024818

Introduction

Before anime and manga became popular, it was difficult to find examples of Japanese art in western pop culture. Most people outside of Japan were introduced to the manga style through countless video games such as *Dragon Quest* and the popular *Final Fantasy* series. As gaming technology was adopted and accepted, so was the style and content. A generation of gamers grew up with Japanese images and stories shaping their imaginations and influencing the development of a new pop culture. Today we see anime and manga style in video games, movies, television, music, comics, books and countless other consumer products extending to handbags and even candies. Manga style is no longer exclusive to Japanese culture. It has become an international style, transcending borders and defining a generation.

Manga Fantasy Madness is an attempt to provide beginning artists with basic instruction for drawing the archetypes and other characters that appear in fantasy stories. Readers can then create their own fantastic worlds filled with heroes, monsters and ancient evil. Don't be a slave to copying what's in the book. Once you get a grasp on the basic concepts, push the boundaries and create something truly original.

Fantasy games, anime and manga are fearless in combining concepts borrowed from other genres. It's not unusual to find time travelers, alien spaceships and giant robots colliding with dragons, wizards and steely-eyed warriors. Mix and match until you find the combination that excites you. Make your own rules. It's your world after all.

Now get ready for *Manga Fantasy Madness*!

Materials
you need

A clean, flat, well-lit drawing surface. Try a drawing table, desk, kitchen table, or even a coffee table.

Paper. Draw on 2- to 4-ply Bristol board sheet or sheets of bond printer paper. You can find these at any office supply store. Experiment with many varieties of paper and techniques until you find what's right for you.

Rulers. Use a straightedge for borders and perspective. Some artists avoid using rulers because it can make an image appear too flat and technical. Make sure your ruler is clean and straight.

Pencils. Regular graphite pencils range from hard (H) to soft (B). Hard pencils (such as 2H or 4H) make light, fine lines that are excellent for hiding under ink, but can scratch the surface of the paper if there is too much pressure. Soft pencils (such as 2B or 4B) make strong, dark marks, but they are hard to erase and tend to smudge easily. Technical pencils make precise, consistent lines and allow for greater control and detail. They are great for artists on the move because they don't require a pencil sharpener. Non-photo blue pencils create lines that are invisible to most photo sensitive methods of printing, but they are visible to photocopiers and most scanners. Keep your pencils sharpened for strong, crisp images.

Erasers. White plastic erasers are preferred over traditional pink erasers because they don't grind down the paper or smudge. Clean your plastic erasers constantly by rubbing them on a clean surface in order to avoid smudges on your artwork.

Inking. Inking is an art in itself, not just tracing over pencil lines. Using the wrong tools can ruin hours of hard work so make sure you are comfortable with your pens and brushes before you start. Use technical pens with permanent ink or a dip-style pen with India ink. You can also use India ink with a brush. Avoid using markers with water-based inks, these may fade or be damaged by moisture.

Coloring. Colored pencils are widely available and easy to use. They come in a wide variety of colors and shades. Colored markers can be difficult to master, but they produce very professional-looking results. Painting your work can be difficult, but the results are often very beautiful. Many manga-ka (comic artists) in Japan are experimenting with paints to create stunning imagery. Most professional artists use software such as Adobe® Photoshop® to color manga. It's still fairly rare to see color manga, but it is getting more popular as production costs drop and more artists publish on the Internet.

traditional
Japanese Legends

Fantasy manga borrows heavily from western European fantasy, and also draws from Japanese folklore. Cultural references and allusions to popular folktales go over the heads of most western anime and manga fans. Some archetypes and concepts keep cropping up and vigilant readers will start making connections to other manga, anime, or video game elements. The following are characters you will find in the most popular legends.

Samurai warriors were born into the warrior (Bushi) class. Samurai are bound to a strict code of honor known as budo, literally the "way of the warrior." The first Samurai were royal guards and police and lived in a time when weapons were outlawed. The members of the warrior class were the only people permitted to possess and use weapons. As their status and importance grew, they were expected to be literate and cultured as well as deadly in battle. Disgrace or defeat was not tolerated and the disgraced warrior was expected to end his own life by performing seppuku, slicing open his stomach with a short sword.

Ninja are super-stealthy assassins, but not much is known about their origins. Ninja warriors became a useful strategic tool for the warlords' battles, often hiring themselves out as elite mercenary spies sent to assassinate rival leaders, scout troop movements, or secretly attack enemy camps or castles. The Ninja's skills are trickery, deceit, stealth and ingenuity. Their weapons include throwing stars (shuriken), split toe slippers (tabi), and the famous hoods that disguise the face.

Ronin are Samurai who weren't associated with a clan. Ronin means "wave man" and refers to how the Ronin was bound to wander life like the waves of the ocean. A Ronin's wandering nature and strict moral code create many opportunities for heroic storytelling.

Kami are numerous divine beings worshiped in the Shinto religion. Shinto was based on traditional Japanese cultural practices. Kami can range from ancestor spirits, to supernatural forces of places, to life forces of plants and animals, to planets, stars, trees, health, love or hate. Any thing or concept could have a Kami or a sacred nature that could be worshiped.

Sennin are immortal holy people that possess supernatural powers through achieving spiritual enlightenment. The Sennin used superpowers such as flying on the back of a carp or a cloud, turning into a giant three-legged toad, or riding a mule that can travel thousands of miles a day.

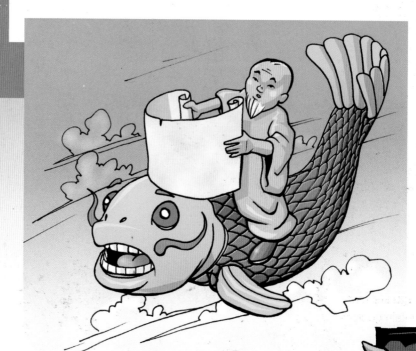

Shoki are demon hunters of Chinese and Japanese legend. They were popular subjects of artwork, as symbols of masculinity and muscle used to ward off bad spirits. Small statues of Shoki often grace the entrances of Japanese homes, looming like gargoyles to scare off evil spirits.

Oni are the monstrous demons from the underworld who range in appearance from huge giant-like ogres to small goblyn-like imps. An Oni usually has long, sharp teeth and wild, bulging eyes. They have clawed feet and hands and a horned head. They act as guardians of the Buddhist underworld and torture the souls in hell.

Yurei is a generic term for a ghost who seeks revenge for a wrong or has business to finish among the living. They were often depicted without legs or feet, dressed in long white funeral kimonos and holding their arms outstretched with limp hands hanging.

Tengu are fearsome mountain goblyns who appear to be half human and half bird. They can shape shift into many forms and delight in causing mayhem such as stealing children, lighting fires and creating tension between people. Their role has changed over the years from trickster goblyn to guardian spirit. Tengu are the legendary originators of martial arts. There are two distinct types of Tengu: Karasu Tengu have the heads of birds with beaks and wings on their backs; Konoha Tengu appear human but have wings and long, comical noses.

Kitsune are magical fox spirits that can assume the form of humanity to carry out various tricks and pranks. Kitsune are considered the messengers of the rice god Inari, probably because foxes cut down the rodent population in rice granaries. They can live for thousands of years. The most powerful gain a silver coat and an extra tail for every hundred years. One of the most touching stories of the Kitsune is the story of the fox woman leaving her child. A fox appeared as a beautiful woman, married a man, and bore him a child. The Kitsune eventually was discovered to be a fox and had to abandon her family. Children of Kitsune often grow up to be successful rice farmers or become rich and famous.

Dragons of Asian cultures aren't the fire-breathing winged lizards of western fantasy. They are composite animals created from pieces of nine beasts: the head of a camel, the ears of a cow, the eyes of a demon, the antlers of a stag, the talons of an eagle, the feet of a tiger, the body of a snake, the scales of a carp and the belly of a clam. Asian dragons represent forces of rain and water, floating on the clouds that represent good fortune and wisdom.

Tanuki are raccoon dogs from Japan who can change their forms at will to annoy and misguide travelers. Tanuki stories often outline the misadventures and misfortunes caused after a bout of boasting and the comic mishaps that occur because of it.

elements of
Fantasy Manga

Manga is a visual story told with sequential images arranged in order, which provides many unique problems that must be solved. Ideas for manga come from the artist, writer, culture, medium, technology and trends. The artist and writer bring their point of view to the assignment and inject their personality and quirks into the project.

Common Themes

- Monsters and enemies are overwhelmingly powerful, often gigantic and unstoppable. Entire cities can be destroyed before the enemy falls.
- The heroes are small, normal people who come from humble backgrounds but can access extreme powers. They often ally themselves with outsiders who possess specific knowledge or skills useful to defeating the enemy.
- A single hero often isn't enough; a team is needed to fulfill the quest. They must work as a team.
- Magical artifacts are incredibly powerful and are sought out by both good and evil characters, but are usually hidden away and protected by horrible monsters.
- Fantasy scenes don't have to look like medieval Europe. Manga artists often borrow heavily from Japanese and Chinese history and myth.

- Steampunk equipment adds a low level of technology to the fantasy setting. Flying machines, clockwork soldiers and steam engines exist beside the typical fantasy elements of castles, dragons and swords.
- Magic is flashy and channeled through powerful sorcerers, often using the spirits of the earth to alter reality.
- The benevolent and all-knowing leader sends the heroes on their quests. Strong and silent, the leader broods over all his or her decisions.
- There is often a connection to the "real world" and the fantasy world.

The characters who find themselves trapped in the fantasy world often discover it as the readers discover it. This allows the readers to explore the details of the fantasy world through an equally bewildered protagonist, creating a direct connection with the story and the characters.

- The look of weaponry, armor and costuming is dependent upon what looks "cool" or "fashionable," not necessarily practical or historically accurate. Some weapons are huge, oversized, and seemingly impossible to wield.

The Video Game Connection

Video games were one of the first forms of media to feature manga- or anime-style characters and be widely distributed. The traditional "heroic fantasy" was adopted by Japanese game makers as a popular genre and in turn spawned countless anime- and manga-based fantasy worlds. These video games were often inspired by literature such as the *Lord of the Rings* trilogy and games like *Dungeons and Dragons* and *Magic: The Gathering*. Fantasy video games continue to develop a huge following internationally and have inspired many anime, manga, toys, Web sites, soundtracks and other merchandise.

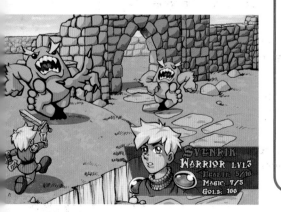

the structure
of the Quest

Telling Fantasy Stories

Sometimes all you want to do is draw cool pictures, but other times a character will find its way out of the end of your pencil and haunt your imagination until you do something—anything—to tell that character's story. In the case of some fantasy stories it can be the story of an entire world or universe.

Ask "What If?"

Writing any fiction is basically answering the question "what if?" Fantasy manga allows the writer and artist greater artistic license than other genres because there are less rules. For the setting in this book, I asked "what if…?" questions before I created them. First, establish the time period. This can range from prehistoric right up to the modern era. For this book I chose to limit the time period to late 16th-century technology and culture, with a hint of some Victorian gothic revival influences such as the topcoats and some fashions. You can pick and choose eras, even combine them. I also added futuristic elements like the steam-powered robots and flying machines. You can also combine elements from other cultures.

Start With a Map

Place all the possible elements you want to deal with in your story on a map. The map can provide further ideas that you would have never imagined. If species such as Elves and Dwarves are involved in the story, then their role and relationships with humans and other species should be worked out as soon as possible. If these details are left until the last moment when they are needed in a story, then you could miss some wonderful opportunities to make something truly original.

Using Archetypes

The character types presented in this book are basic archetypes of some standard fantasy characters. Archetypes allow readers to quickly understand the basic idea of the character in one or two words. "OK, he's a Noble Paladin." To make things really interesting, try throwing something totally random into the mix such as a Noble Paladin who has been struck blind and must organize the defense of a village against a horde of demons. The challenges heroes face are also archetypes of sorts. Personalize every character—even a City Guardsman might have a fear of Elves or a scar from a past battle.

Heroes and Villains

What makes a hero a hero? The hero of a manga is usually the main character, but they don't have to necessarily be the "good guys." Manga rarely looks at the world (even fantasy worlds) as simple black and white. Huge areas of gray are allowed; keeping the reader guessing about what the character might do next is only part of the reason for this.

Remember, the "bad guys" are characters too. Avoid the snarling villain rubbing his hands together, twirling his mustache and cackling over his next evil scheme. They should have convictions that what they are doing is right. This makes it harder for the hero to stand up to them, especially if what they are doing is logical or at least sympathetic.

Recipe for a Hero

- Start with a clearly definable archetype such as the warrior, wizard, orphan, wanderer or martyr.

- Put that character into a world that seems normal, but has some sort of overall threat or menace upsetting the natural balance.

- Add an unusual birth or strange origin story.

- Add a dash of "something happened to my parents."

- Mix in a seemingly negative characteristic that eventually becomes the personality trait that helps save the day.

- Introduce a call to adventure, but have the hero refuse to go until he is forced to.

- Combine with an aged mentor who can guide the hero on the journey and provide wisdom and magic items when they are needed.

- Surround the hero with danger and provide a series of challenges that must be overcome.

- Let the hero understand the true nature of his power and set about to right the injustices of the world with a little help from his friends.

- Bring to a boil and in the confusion let everyone think that the hero has failed. Everyone should feel really bad, but you know better.

- Have the hero return in glory and be handsomely rewarded by a grateful world now that order has been restored.

planning your
Manga Fantasy Quest

The heart of any fantasy story is the quest of the hero. This pattern has been developed since the first stories were told and not much has changed to alter the structure of the heroic quest. Every story has to have a beginning, middle, and an end. Order is shattered with an inciting incident. This is usually because of an imbalance of power, energy, or other force.

Develop a series of conflicts that get progressively harder in rising action. This is the bulk of the story where we learn more about the hero and the opponents and what must be done to restore balance to the world.

The conflicts build up to a climax where the secret is revealed, the foe vanquished, etc. This is the point in the story when events lead in one direction or another.

The story is resolved and loose ends are tied up.

Using the Monomyth

Campbell's Monomyth presents a compelling structure for fantasy stories, but it's easy to see how creating stories this way can become repetitive and boring. To avoid the danger of falling into predictable rhythms you may want to deliberately undermine the structure. For example, you could make the mentor character reveal that they are the villain in the end. Or have the rescue of the hero end in the death of the would-be rescuers at the hand of the villain. Once you understand the structure you can start messing with the archetypal pattern to create something surprising and new.

The Heroic Journey

Psychologists, anthropologists and literary critics have discovered that many of the themes, characters and structures of the heroic quest exist in cultures around the world. The model of the heroic journey was called the monomyth (one myth) by Joseph Campbell in his book *The Hero With a Thousand Faces* (1948). Campbell states that all myths basically follow the same structure. Manga, anime, and video games all follow various versions of the monomyth to tell the story. Once you know and understand the structure, recognizing the stages of the hero's journey in media and literature can be an awful lot of fun.

The Call

The hero, who is embroiled in personal turmoil, is suddenly called to adventure by an outside figure who challenges him to leave his familiar surroundings and set out on a noble quest.

The Call Is Refused

Sometimes the call is refused and the hero's personal turmoil gets progressively worse until the quest is undertaken (usually the hero is given no choice).

The Mentor

The helper or mentor gives the hero mystical information and a powerful magical item to help succeed in the quest.

The Point of No Return

The hero must leave the comfort of his home and set off into the unpredictable world of adventure. The first challenge is often bypassing a guardian so he can leave the familiar world behind.

The Belly of the Whale

After getting past the first guardian, the hero is suddenly totally immersed in the new world with no way back. This challenge provides the opportunity to demonstrate true heroism by saving the day.

The Road of Trials

A series of tests confronts the hero, letting him hone his skills and gain

Getting Advice From the Mentor

Getting Past a Series of Tests

knowledge to eventually defeat the ultimate enemy. One reward for diligent training is an encounter with a goddess-like character who somehow helps him in his quest (the genders are usually reversed for heroines). The hero is then distracted by temptations of lust or greed that threaten to derail the success of the quest.

Reparation With Father Figure

The father figure (or mother for a female hero) may not be the hero's true parent, but may be simply a parent-like leader or opponent. The hero must somehow gain the blessing or understanding of the parent in order to understand what he will become himself. Once he understands his fate, the hero becomes almost unstoppably powerful and learns how to balance his inner turmoil and bring order to chaos. The nature and weakness of the villain is

often revealed connecting the hero to the villain somehow.

The Return

The hero should be given the chance to escape the perils of the adventure and live happily ever after without having to solve the world's problems, but the hero, being the hero, pushes on despite the promise of personal happiness in order to make the world a better place.

The Magic Flight

The hero must travel quickly to a location to perform the event that will save the day. This is often a chase or a running battle, and is sometimes a real flight of technological or supernatural means.

Rescue of the Hero

The hero may find that he needs to be rescued from a threat as he under-

takes the climactic events that will end the story. This is usually a big surprise to the hero, the villain and the audience.

The Final Guardian

The final guardian is the last big battle the hero must endure before he can restore order and go home. The hero's newly honed skills, supernatural powers, magical item and knowledge of the villain's weakness all tip the balance to help him win. The hero symbolically overcomes the turmoil he was suffering at the start of the story.

The Return and Reward

The hero returns to his home, is rewarded by the community and then uses his new skills and powers to make the world a better place.

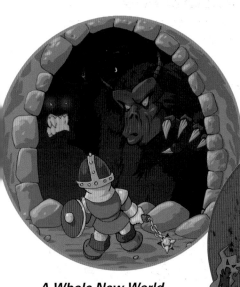

A Whole New World

Gaining an Understanding

The Hero Travels to Save the Day

The Community Rewards the Hero

heroes of *the* Kingdoms

Fantasy heroes are usually young, optimistic, and on a collision course with forces much more powerful than they could even imagine. They also seem to be outsiders in the culture in which they live, rebelling against social and cultural norms to bring back the "golden age" of the glorious past by defeating the corrupting villains. Establishing order out of chaos is one of the key roles of the fantasy hero. It's in that spirit that the world of the Kingdoms was created. Populated by traditional fantasy species such as Elves and Dwarves there is also a strong medieval-Europe-meets-medieval-Japan culture clash underlying an epic struggle of demonic invasion. The heroes are out to tame the wild forces of chaos that threaten to destroy the human, elf and dwarf civilizations. These are just a sample of the heroes you can create!

Lovable Rogue

Thieves and spies are not always appreciated in real life, but in fantasy stories the Loveable Rogue can open doors, disarm traps and sneak past the most vigilant guards.

Elfin Archer

Elves have a traditional connection to the land, so when the world is threatened it just makes sense that they would leap to its defense.

Trusty Dwarf Warrior

If the Elf represents the forest and spirit of the earth, then the Dwarf represents an earthier, subterranean connection to the well being of the fantasy world.

Princess Warrior

Often the Princess is a maiden needing rescue, but manga heroes would never stand for that. Manga princesses are feisty and pretty good with a sword.

Youthful Wizard

A young wizard learns the secrets of magic along with the reader. It's no fun to read a story about a character who has no challenges. Make them sweat a bit trying to remember the words of a spell as they fend off sword strikes with their magic wand.

Noble Paladin

The ultimate knight in shining armor sets out on his quest with unshakable resolve and faith. He is almost unstoppable against the forces of darkness, but has some dark secret or hidden weakness.

Bounty Hunter

Ruthless and persistent, the Bounty Hunter roams the land exacting justice for profit—his profit. He may be on the side of the heroes, but he'll work for the side with the biggest payout. His biggest question is, "What's in it for me?"

Youthful Adventurer

He is the classic hero of any fantasy adventure. The Youthful Adventurer must leave his or her simple village and set out into a big bad world to fulfill a quest that seems almost impossible for someone so young and inexperienced. Youthful readers really identify with this kind of hero because they see themselves represented.

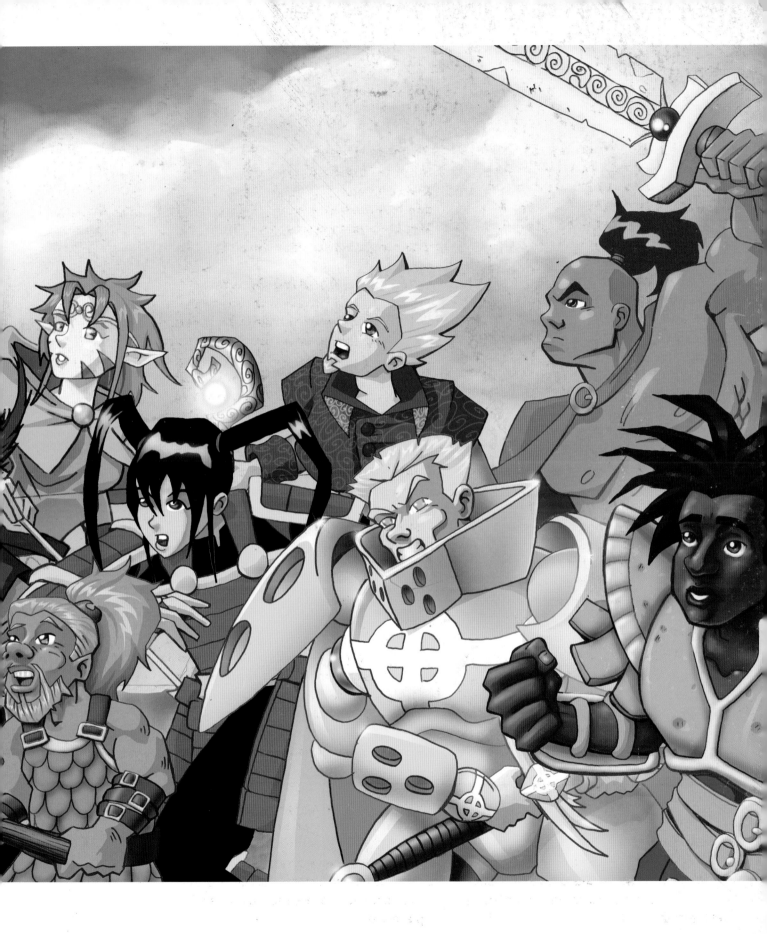

scum and Villainy

Fantasy villains come in all shapes and sizes—literally. These dark characters wait around every dismal corner and lonely forest glen in the fantasy world. Create your villains to be just as interesting as the heroes who fight them. Manga traditionally explores the reasons why the bad guys behave so badly, often turning them into sympathetic characters who can become even more popular than the heroes.

Dragon

Probably the most ancient of all fantasy villains, the dragon is the ultimate symbol of nature's fury and primeval power. Dragons usually guard treasure and are often the ultimate challenge for a group of heroes.

Corrupt Noble

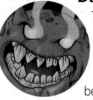

You have to hate this guy—he holds all the power and abuses it horribly. He's smart and ruthless, and he's always on the trail of the heroes with legions of supporters and superior firepower, but he's so egotistical and self-obsessed that he often makes stupid mistakes, allowing the heroes to slip through his fingers once again.

Lizard Creature

Part of the inhuman forces that confront humanity, the Lizard Creature can have insect qualities. It is menacing because of its inhumanity and dangerous abilities.

Dark Elf

Unlike Elves, Dark Elves emerge in the darkness of the forest and unleash the fury of nature upon an unsuspecting world. For every light there is a shadow.

Mindless Guard

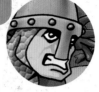

He sets out to capture the heroes and enforce the will of the Corrupt Noble, but his simple lack of personality and development means that he is doomed to fail every time. Just don't tell the heroes that or they'll become smug.

Demon

The Demon is a primal force of evil loose in the world. It usually feeds on destruction and chaos. Large and powerful, it often shrinks away from beings of purity and true faith.

Goblyn

The forces of fairyland are not always fairytale sprites and pixies. Most are malicious little imps who delight in mayhem and misery. Goblyns are organized in loose clans that constantly battle one another but form a formidable unified force against a common foe. They grudgingly support larger creatures like Ogres or Demons by acting as cannon fodder for their destructive aims.

Wicked Witch

The Wicked Witch has spent eternity casting spells and curses using black magic, and is in a single-minded pursuit for more power. She's a good example of what can happen to someone who messes with forces that were never meant to be touched.

Ogre

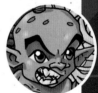

Big and ugly, the Ogres and their larger cousins the Giants lumber across the land wreaking havoc and destruction. Tales of Giant and Ogre killers are very common in fairy tales and mythology. Ogres hoard treasure like dragons. They often cause great devastation in their quest to destroy the Dwarves and Elves.

Necromancer

This evil wizard uses black magic to reanimate the dead and make them do his bidding. Creepy and crazy, the Necromancer is more ghoul than human, smelling of decay and death.

Warrior Skeleton

Zombies, skeletons and other undead creatures are classic fantasy opponents because they represent a primal fear of decay, death and being cursed by restless ancestor spirits that make the dead walk. Usually all it takes is a good smash with a club to take a warrior skeleton down, but there can be so many of them it's easy to be overwhelmed.

Slimy Blobby

The Slimy Blobby oozes along leaving a trail of slime, engulfing and absorbing victims with it's acidic mucous. Slicing it just cuts it into many smaller blobbies and only magic or fire can destroy it. Eww, gross!

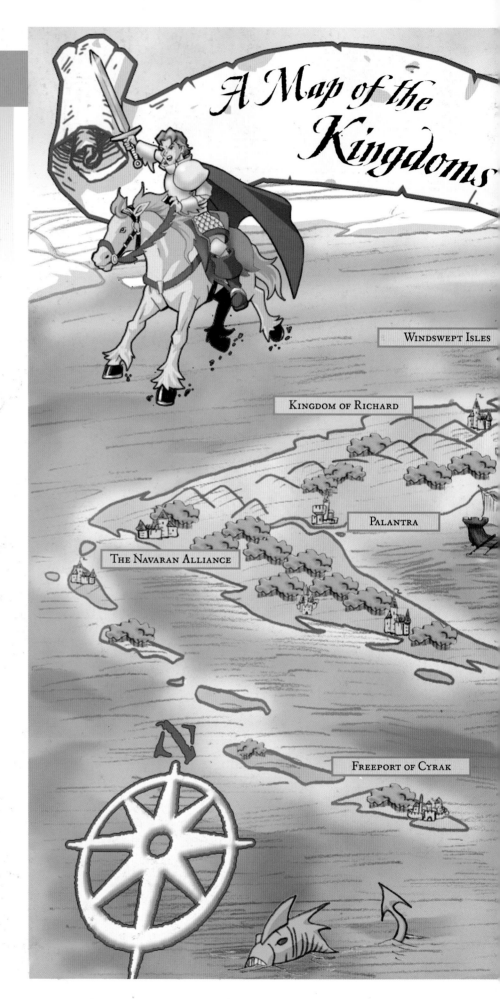

A Map of the Kingdoms

WINDSWEPT ISLES

KINGDOM OF RICHARD

PALANTRA

THE NAVARAN ALLIANCE

FREEPORT OF CYRAK

The proud and powerful Radaran Empire had once united the land for a thousand years. It seemed that the empire would solve all of mankind's problems. Peace with the Elves and the Dwarves was close at hand. The rule of law extended to all of the known world and great advances in culture and technology created a golden age of reason and harmony. But the sudden migration of millions of Cathasians from the East ripped the Empire in two and foretold an even greater tragedy that would soon occur.

The Cathasian refugees were warned of an approaching catastrophe by an ancient prophecy, and so took over a vast area of the empire west of the Dwarf Hills. They erected a sturdy wall to keep out intruders. On the day the wall was finished the forces of chaos were unleashed upon the Wizard Kingdoms and shattered the peace of empire. A great cataclysm tore apart the northern lands. Magic portals unleashed wave upon wave of monsters from terrifying worlds of gloom and evil and the great Wizard Kingdoms were laid to waste. The forces of chaos drove the people from the northern lands and fractured the once mighty empire into a collection of warring kingdoms and city-states.

A thousand years have passed since the fall of the Radaran Empire and the land has yet to recover from the sweeping upheavals it experienced so long ago.

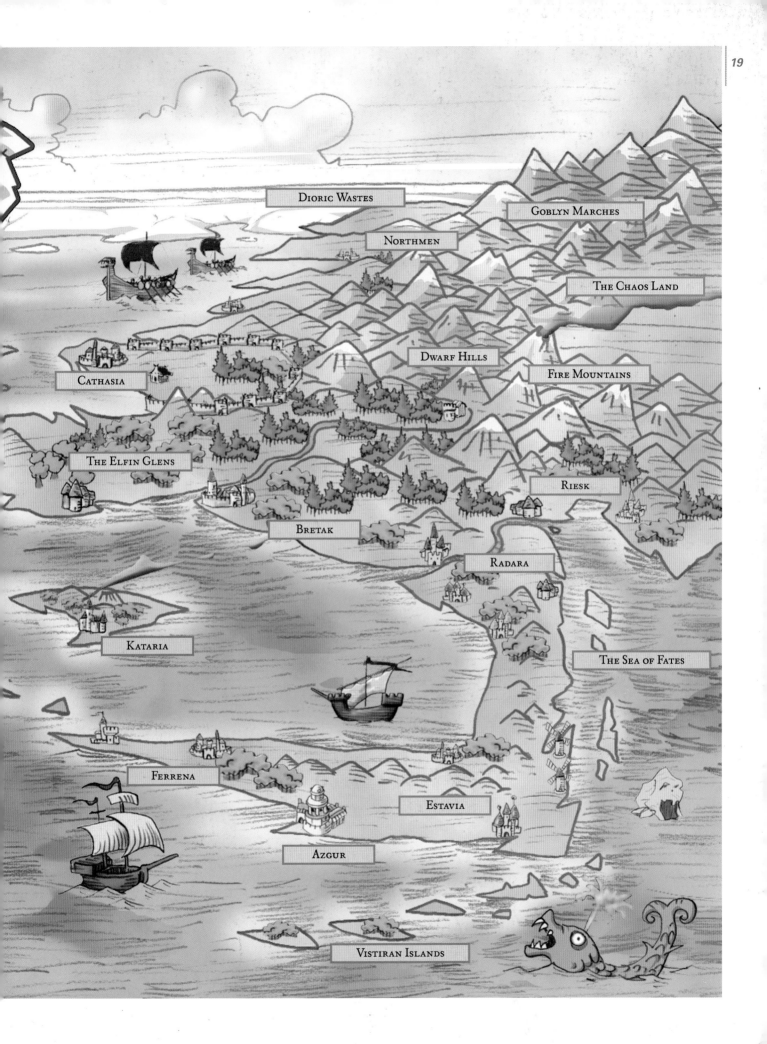

DIORIC WASTES

GOBLYN MARCHES

NORTHMEN

THE CHAOS LAND

DWARF HILLS

FIRE MOUNTAINS

CATHASIA

THE ELFIN GLENS

RIESK

BRETAK

RADARA

KATARIA

THE SEA OF FATES

FERRENA

ESTAVIA

AZGUR

VISTIRAN ISLANDS

drawing Basics

Do your drawings look flat, mis-shapen, or out of proportion? It happens. One way to improve your skills is to practice drawing from real life everyday. Observe the world around you and notice how objects are made up of some very basic shapes: circles, squares, rectangles, and triangles. Don't forget that objects in real life exist in real space. The "shapes" are actually 3-D forms: spheres, cubes, cylinders and cones. By combining these basic 3-D forms you can create any object you can imagine. This is handy when you are dealing with the world of fantasy.

Practice Drawing Basic Forms

To improve your skills practice drawing lots of spheres, cones, cylinders and cubes. The biggest mistake beginning artists make is trying to make a totally finished drawing without any planning. Blocking in basic forms will help deconstruct complex images into manageable chunks. Drawing this way helps remind you that the images are supposed to be depicting an object in real space.

See People as Basic Shapes

Break down the human body into basic shapes. You'll see that the human figure is actually just a collection of cylinders and spheres. Combine this concept with rules of anatomy, proportion and perspective and you can realistically draw anything you imagine.

A Skeleton of Shapes

Just under the surface of the finished work lies the basic shapes and forms that help create the final image. Notice how details such as kneecaps and the width of the torso are indicated even though they are not always totally obvious in the final image. This technique is called "drawing through" and it helps ensure that everything fits where it belongs in relation to everything else. These extra lines are usually erased in the final stages of the drawing. Details such as hair, facial features, clothing and other equipment may not be indicated in the initial scribbling. Keep your construction drawing loose, but don't forget the basics of proportions and anatomy. This dwarf, for example, uses different proportions than a standard human. You can modify the rules to suit what you are doing. Just be consistent.

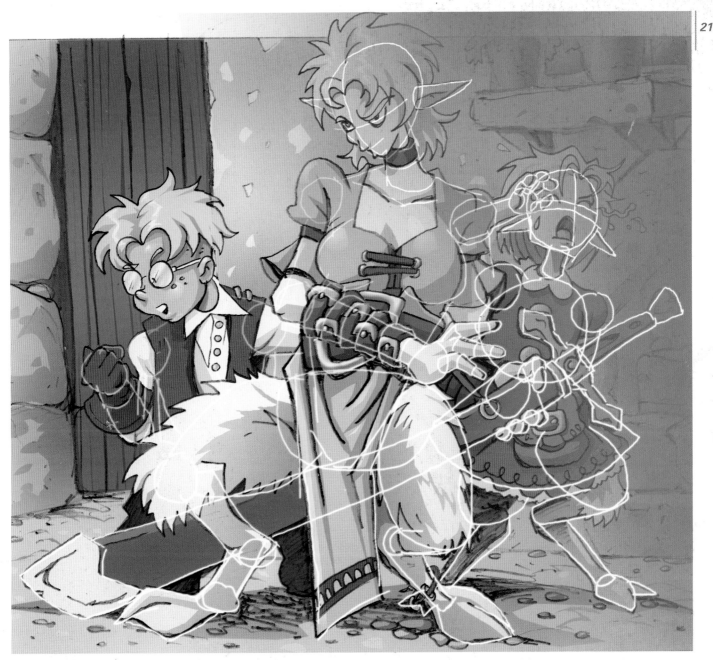

Solve Problems With Construction Lines

The construction lines are the blueprint of the final image. Complex anatomy issues can be resolved early on and relationships of characters, objects and settings can also be established. This way, if you need to fix something you don't have to worry about ruining an image you have poured your heart and soul into.

If You Build It

Rough out construction lines when you start a complex drawing. Draw lightly and carefully. Too many lines can become confusing and heavy lines are difficult to erase. Keep a file of poses and action shots made entirely of construction stage drawings. This way you can modify the details to suit any character as you finish the drawing. After a while you may not need to develop every drawing as a construction drawing, but even experienced artists find it helps them draw quickly and accurately. Your construction sketches may have more or less detail right from the start. Some artists use looser, scribbled lines (known as gesture lines) to quickly block in the form, weight and movement of an image.

Shading
and 3-D effects

Shapes look flat until you include 3-D information. You can block in this information with lines or use careful shading to show highlights, tones, shadow and reflected light. Your shading should have four to six levels (or values) of gray from the lightest to the darkest.

How to Shade

1. Establish your light source direction. Where is the light coming from? The spot on the object that the light hits should appear to be the lightest area on the form.

2. Drag your pencil or brush and follow the form of the object that you're shading. Imagine you are wrapping the forms in string and each pencil or brush stroke is a strand. Your pencil lines should literally wrap around the form.

3. Build up light areas of hatching and crosshatching with the tip of your pencil. Keep your pencil sharp. The more fine the lines, the more lines you can draw. The more lines you draw, the smoother the shading will appear.

The Smudge Factor

When you are shading, be careful not to smudge. Smudging almost always just removes two or three levels of value.

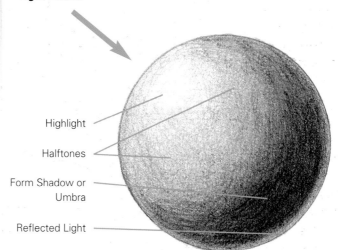

Light Source

Highlight

Halftones

Form Shadow or Umbra

Reflected Light

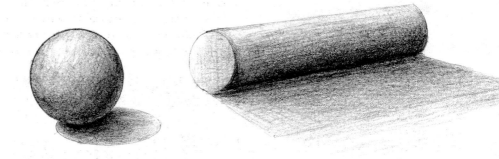

Understanding Light and Shadow

When you shade, you are looking for light areas and shadows on a form. Figure out where your light source is and keep the direction consistent for every object in your drawing. Highlights are the lightest areas of the objects. Leave highlights white or very light: the whiter the highlight, the more reflective the surface. Surrounding objects and other light sources can also reflect light onto your form. Halftones should blend into each other smoothly along the surface of the object. Sharp transitions of light to dark will make the surface appear angled and pointy. The areas in shadow will be the darkest on your form.

fantastic Color

The majority of the illustrations in this book were done using computer software. This is how most professional comics artists color their work, but it doesn't always have to be that way. Many illustrations of fantasy manga are produced using traditional drawing and painting techniques to maintain a more natural and organic look. Artists use colored pencils to develop color studies and make some beautiful images as well. You may also find success coloring with markers, but they can be unforgiving and rather expensive when you are starting out. Some artists use watercolor or acrylic paint to create some stunning effects.

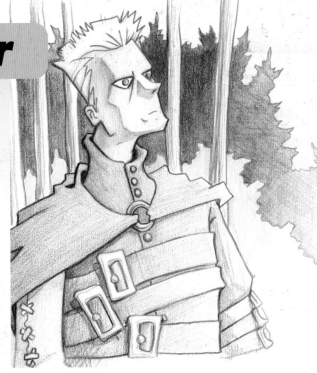

Build Value With Colored Pencils

Gradually build up the areas of color with hatching instead of pressing down on the pencil to create a solid color. Whenever possible, use the crosshatching to help describe the forms you are shading. Using colored pencils to outline the drawing instead of black ink further softens this technique. Make sure your colored pencils are sharp to ensure total control.

Use Colored Paper

Try drawing on colored paper with colored pencils. This image was created with a web of hatching to show areas of lightness. Drawing this way can be tricky because we traditionally use a dark pencil on light paper. The mental switch can create a very cool look for the final image. Use references to generate convincing textures and surfaces.

Combine Acrylic Paint and Colored Pencil

computer Coloring

Computer coloring produces the some of the most polished and professional images. This is a quick overview of one technique. Experiment with various programs to see what you are comfortable with in your own art. I am using Adobe®Photoshop® for this demonstration.

1 Scan the original line art on to your computer at a minimum of 300 DPI (dots per inch). Some projects may require 600 DPI, but 300 DPI is sufficient for printing on standard 8½" X 11" (22cm x 28cm) paper. Clean up the scan by increasing the brightness and contrast and using a graphics program such as Adobe®Photoshop® to remove any smudges, dirt, or unwanted slips of the pencil or pen.

2 Create a separate layer on top of the line art, then block in the areas of color based on your drawing. These areas are not yet shaded or highlighted and appear to be flat sections of color. The flat color layer should be set to multiply or otherwise let the black line art show through for the final image. For an even softer illustration you may want to color the line art a darker version of the color in the lines.

3 Use the mask or select tool to choose areas that will appear darker. Use references as a guide to choosing areas of shadow and be careful with your shading. The image doesn't have to appear realistic, but it should have a coherent internal logic including a consistent light source.

Selecting Graphics Software

Coloring images on the computer has greatly increased the quality and attractiveness of artwork. The program you choose to use will depend upon your needs and finances. It may not always be practical to use high-end software like Adobe® Photoshop®. The best things to look for in a software package are:

- The ability to save in multiple formats (.tiff, .jpg, .gif, etc.). This allows the greatest flexibility for sharing your artwork with the world, whether you are sending an e-mail of the images to a friend or posting them on a website, the more options you have the better.

- The option to select specific areas of the illustration with masks. Selecting specific areas using masks allows you to modify the chosen area and keep the rest of the image untouched.

- The ability to organize colors using layers over the original artwork. Layers are the key for total control of the illustration's colors. Layers can be overlapped and colors can be faded or enhanced all without affecting the original artwork.

4 The darkened area should help define the form of the character. This definition is clear when you look at the image without the black outlines. If the image appears 3-D without the lines, then the image is just about fully shaded.

5 Use the mask or select tool again, but this time select the areas that will appear lighter and create a highlight on the figure. This highlight is important because it completes the illusion of shading. You can lighten the existing area of flat color or you can create a new layer that covers line art and flat color alike.

6 Develop the image until you feel it has enough variety of shadows and highlights. The color layer should appear 3-D on its own even without the line art.

7 Make the line art visible again by selecting the original layer where you scanned it. The line art brings it all together and cleans up the edges of the image. This way of coloring mimics the "cel shading" style—painting an acetate cell as in traditional animation—found in cartoons and some computer games.

Face
front view

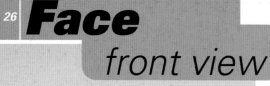

Keep things symmetrical when you're drawing a face. Experiment with all kinds of shapes to see what kinds of heads you can create. Every character will be slightly different. This character is a young hero. We know he's young because his eyes are large and wide. In manga characters eyes seem to get smaller as they age. Try using a real person as a reference for expressions, facial structure and other details.

1 Lightly block in an egg shape with intersecting horizontal and vertical lines. The human head is usually five eyes wide with one eye space separating them in the middle. Block in the eyes, nose, mouth and ears. Eyebrows don't touch the eyes when viewed from the top. The base of the nose is located about one third between the eye line and the chin. The mouth is roughly a third of the way down from the base of the nose. Realistic mouths are wide enough to end at the center of the eyes. The ears are as large as the space between the eyebrows and the base of the nose; block them in as simple curves.

2 Add the hair, rising up and off of the head. Define the chin and other details of the face.

3 Clean everything up and define the lines. Either erase the construction lines or trace the image onto a new sheet of paper. In some manga and anime, hair is often drawn through to reveal eyes and eyebrows underneath, almost as if it is transparent.

Creating a Creature

The same rules for drawing humans don't always apply to other types of fantasy creatures. Just be creative, think things through and keep the proportions consistent.

Face
profile

Although it appears deceptively simple, the profile can be one of the most challenging views to draw. Remember to draw the entire skull so the character doesn't have that "caved in head" look.

1 Draw an egg shape within a square. Divide the square into quarters. The horizontal line halfway down the square is the eye line. The vertical line is where the ear will be. Draw the eyes like a wedge shape. Place the eye about one eye space in from the edge of the face. Draw the nose roughly one third down from the eye line to the chin. The mouth line will be one third of the way down from the nose. Keep your lines light. Clarify the location of the mouth and ears and curl the lower part of the skull up behind the ear. The head rests on the end of the neck leaning forward. Don't just draw lines down to indicate the neck.

2 Block in the hair and define the facial features. Make the hair rise up off of the head. Darken the facial features. Draw the nostril flat, not big and round. Keep the mouth and lips simple; give the lower lip the most definition.

3 Erase the construction lines and redefine the final lines of the drawing. You'll be grateful you drew so lightly in the early stages. If the lines are too confusing or are hard to erase, trace your final image onto another piece of paper.

1

2

3

Exaggerate Features

Other creatures call for other approaches. Notice how this head has a much larger nose and oversized ears. These exaggerated features define a unique head shape.

Face
3/4 view

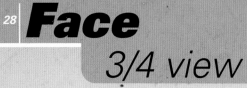

The challenge of this view is to make sure you draw the back of the skull and not cut it off by drawing it too small. We always forget we have all the head back there.

1 Draw two horizontal lines for the top and bottom of the head. Draw two egg shapes, one slightly tilted and the other tilted back just a little. The edge of the second egg is the axis of the face. Block in the eye line halfway between your head guidelines and indicate the other features. Wrap the lines around the head and don't just sit them flat. Lightly block in the basics of the face. Each eye has a distinct shape in this view. The closest eye is similar to a standard front view eye; the farthest eye is more curled around the shape of the head in a more teardrop shape. Draw the indentation of the cheekbone and the brow ridge with a wide arrow point that breaks into the egg shape. Quickly draw the nose, mouth and ear, making them look 3-D.

2 Draw the hair, nose, mouth, neck, ears and eyes. The eyebrows are one shape instead of individual hairs. The hair rises above the skull and the nose appears to rise off of the surface of the face. Avoid drawing huge nostrils—from this angle you won't see right up in there. Manga keeps details such as lips and teeth simple, but adding more realistic detail may be part of your individual style, so experiment.

3 Clean up the details and lines. You can even trace your original art onto another sheet of paper.

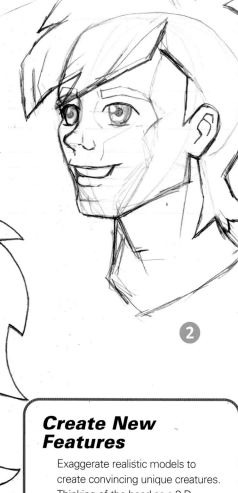

Create New Features

Exaggerate realistic models to create convincing unique creatures. Thinking of the head as a 3-D object helps define the forms in a more believable way.

standard **Proportions**

Every individual has its own proportions, but we also share a common anatomical structure with some small variations: some people have shorter shins, others inherited longer necks. Proportions are really about how every part of a figure relates to the next part. Manga proportions are inspired by realistic proportions, but are exaggerated, just like other features. The examples that follow help define a few standard proportions you may need in a fantasy manga. Feel free to modify the rules to suit your characters.

Adult Proportions

- Adults range from 7 to 8 heads in height.
- Eyes are usually smaller and less expressive, suggesting maturity and experience.
- The neck is about ¼ of the head's height.
- The width of the shoulders is roughly two head heights.
- Males have a bulkier upper torso than females.
- The hands are about the size of the face from the chin to the eyebrows and the wrist is usually located just below the center line of the figure.
- Female hips are slightly wider and start somewhere higher on the figure.
- Male hips are usually as wide as the ribcage, but not as wide as the shoulders.
- Legs and feet should take up half of the total body height.

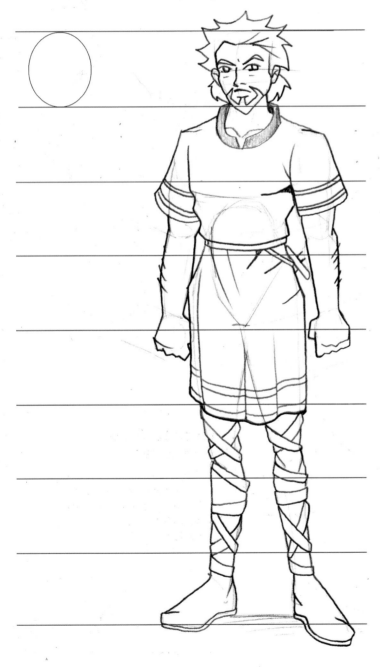
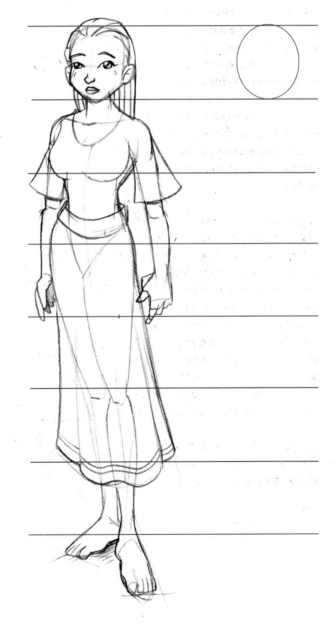

Youth Proportions

- Teenagers and young adults range from 7–7½ heads tall.
- Eyes are usually larger than adult eyes, but this can vary.
- Large eyes suggest youth and innocence.
- Closed eyes are playful and add a childish touch.
- Shoulder width is roughly ½ to 2 head heights. Younger characters have more narrow and rounder shoulders.
- The neck is about ¼ of the head's height.
- The build of the torso and musculature is toned down and less squared off than the adults.
- The hips are usually just as wide as the adults, but appear more fluid and expressive.
- Wrists begin about halfway down the figure.
- Larger hands and feet add a sense of gawkiness and unease.

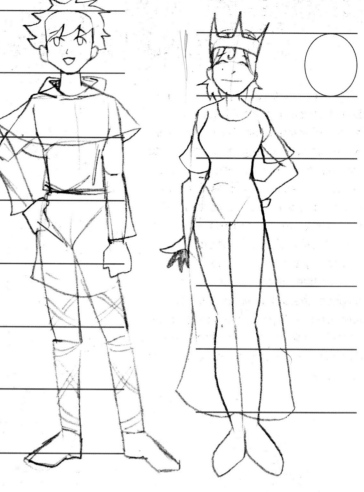

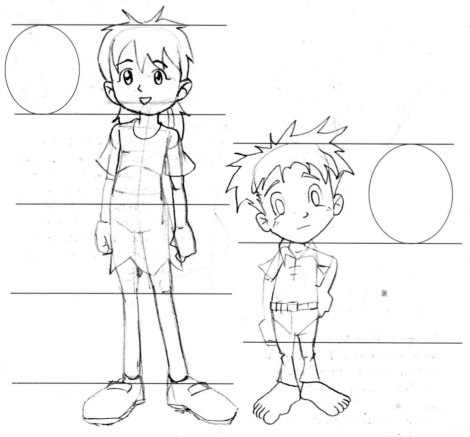

Child Proportions

- Most kids are 4½ to 5 heads tall, but their proportions change dramatically as they age. Younger children and toddlers range from 2½ to 3 heads tall.
- Children don't have muscle definition. Keep the features hidden with a bit of baby fat.
- The head appears large because the body is smaller.
- Eyes are usually huge in comparison to the face.
- Wrists are not bony or narrow. The hands should appear to come out of the arm in a rounded, rubbery way.
- Hands and feet appear large because they are still roughly based on the proportions of the face and the body is smaller.
- The neck is thinner than the adult or youth.
- Shoulders are often only 1 head height wide, but are often even smaller in younger characters.

archetype
Proportions

Different character types have different proportions. Realistic human characters may be 7 heads tall while heroic characters may conform to the ideal of the hero standing 8 heads tall. Other creatures such as Elves and Dwarves have their own proportional formulas. Elves are long and willowy at 8 heads tall while Dwarves are short and stocky at around 3½ heads tall.

Note that the proportions and the height of the character are two separate things. A fey may have the proportional formula of a human child (roughly 4 heads tall), but only measure 8 inches (20cm) tall.

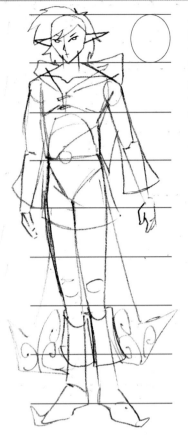

Elf Proportions

Elves are often depicted as classically proportioned beings that are finer featured than humans with long graceful limbs and outrageously pointy ears.

- Elves are roughly 6 feet (183cm) tall.
- Manga and anime elves have amazingly large ears.
- Exaggerating the classic anatomy proportions makes Elves appear less human and almost too perfect.

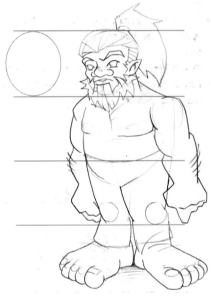

Dwarf Proportions

Traditionally short and stocky, the Dwarf is somewhere between 3½ to 4 heads tall. Keep the centre of gravity low and make sure they aren't too skinny looking. They would be roughly 4 or 5 feet (122cm to 153cm) tall.

- The head is much larger than the body. Dwarves are known for their thick skulls.
- The biggest difference is in the legs. Dwarf legs are short and strong.

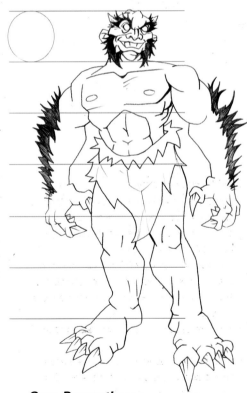

Ogre Proportions

The Ogre is big, bulky, muscular and dangerous. Don't let his big smile fool you, this Ogre is probably more hungry than friendly. Ogres can range from 9 to 12 feet (275cm to 366cm) tall. Larger Ogres are known as Giants.

- The arms are strong and muscular.
- Hands and feet end with powerful claws used for tearing apart their prey.

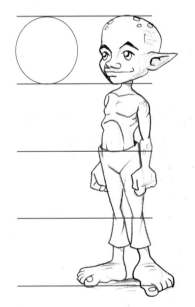

Goblyn Proportions

Keep them scrawny and lean with large hands and feet and a comically huge head. Goblyns are roughly 4 feet (122cm) tall.

- Sneaky and sly goblyns are 4-4½ heads tall.

Kitsune Proportions

Tiny, slight and almost cat-like, the Kitsune is an enchanted fox spirit from the fairy realm. Kitsune are 3 to 4 feet (92cm to 122cm) tall.

- They have big bushy tails and gain a tail every thousand years.
- The figure should look very youthful and childlike.

Fey Proportions

These fairy creatures flutter around and have child-like proportions. Keep the heads big and don't forget the insect-like wings on the back. Fey are creatures of magic and can stand anywhere between 8 inches and 1 foot (20cm and 31cm) tall.

- The antenna reinforces the insect-like appearance of the Fey.
- The wings were modeled from a dragonfly.

Monkey Proportions

This is no ordinary monkey; he's an enchanted guardian of a jungle temple. The tallest stand roughly 4 to 5 feet (122cm to 153cm), but they usually run around on all fours only standing to reach something, or scare away enemies.

- Unlike apes, monkeys have tails they can use as an extra limb to hang from branches.
- The monkey is long and lanky with opposable toes that allow him to use his feet as hands.

Pixie Proportions

Pixies are even less human than the Fey and you find multitudes of them in fairyland. They have strange leaf-like wings that somehow allow them to fly. No two Pixies appear the same, some have one antenna and others have four. Some have small wings and others have huge wings. They range in height from 1 to 2 (31cm to 61cm) feet and are known for their mischief.

- Keep the body small, almost Kewpie doll cute.
- Simplified features make the Pixie appear less human and more alien.

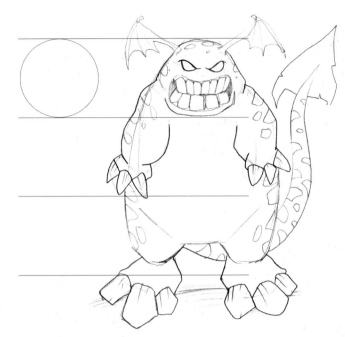

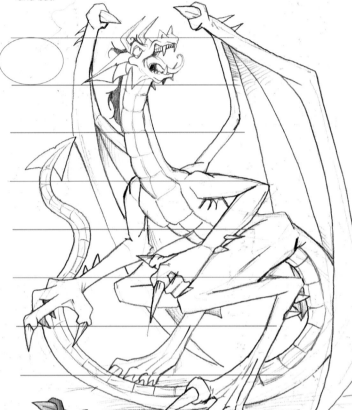

Dragon Proportions

The Dragon is over 90 feet (27m) long from snout to tail. When it is crouched on its hind legs it is roughly 30 feet (9m) tall.

- The dragon's wings are strong and bat-like. Even though they appear large, realistically a flying creature of this size would have even larger and stronger wings.
- The features of the face are a strange combination of a wolf, crocodile and bat.

Demon Proportions

He's huge, deadly and probably stinks of brimstone. The demon is designed to appear inhuman so the proportions are more of a reflection of its nature than its anatomy. Demons can be all sizes, but the most dangerous ones are huge, towering some 25 to 30 feet (8m to 9m) tall.

- The bat wings on its head could probably never lift the demon off the ground, but they reinforce its evil nature.
- Twisted and bloated, the demon looks like it is pulsing and writhing.

Make a Size Comparison Chart

This chart shows the differences in height between some of the major species. Feel free to vary their characteristics. You may have a personal vision of Elves being shorter than humans or that Lizardmen being hulking beasts the size of ogres. Keeping a size comparison chart helps you keep everything in order when you envision all the monsters that might inhabit the world of your imagination.

Foreshortening

Foreshortening is a way to show depth of field in a drawing. It also makes your art much more dramatic and exciting. Foreshortening is a technique of perspective that makes objects or parts of objects appear to be coming out at the viewer. The closer the object is, the larger it will appear and vice versa.

Block in Basic Shapes

Foreshortening is simply showing structure of an object in perspective. Blocking in basic shapes instead of trying to draw the perfect details at the beginning lets you understand the construction and structure of what you are drawing.

Looking Down

Foreshortening distorts the figure to show depth.

Foreshortening Shows Action

Use Photo References

Photo references can help with foreshortening. This image shows the foreshortening of the arm throwing the punch, but it also shows the figure as if the viewer is looking down at it. Photo references correct the parallax error we experience when we see an object coming towards us. Our two eyes have a difficult time putting the image together as it approaches so we see two fists coming at us. Closing one eye is a solution to correcting parallax error, but the camera does this automatically for us as it has only one lens.

Action poses

Manga Fantasy is full of action, so don't just draw your characters standing still. Although some poses can be subtle, make sure to always reveal something about your character's personality.

Choose Your Angle
Which angle is the most dynamic angle to show an action is a personal one. From the side, the figure is sort of flat and uninteresting, but more details of the figure are revealed than in the leaning forward view of the front. The arrows indicate the direction of the limbs and body, either toward or away from the viewer. It's always good to experiment with poses until you get the one that expresses the energy and intent of the movement you are trying to convey.

Describe Your Actions
This pose of a leap reveals much about the nature of the jump. The fact that the hair is flying back and the loincloth is pushing back shows that the figure is leaping forward and landing, not taking off.

Reveal Character Traits
Try out different poses that help express actions, but also reveal something about the character. Even without anatomical or costume details this figure appears to be a gymnastic, flexible character, probably a thief or an acrobat.

Boring: Avoid Static Action Poses
This figure isn't in a very dynamic pose. Dynamic poses excite the viewer and create a much more interesting and energetic result.

Exciting: Always Show Movement
Try to show movement in all of your drawings. Characters who are just standing there are dull. Combining the rules of proportion, anatomy and perspective can create dynamic drawings.

Battle stances

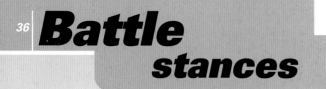

Drawing convincing combat sequences is challenging. Make your scenes dynamic—show more than panels with stiff figures just standing around, moving their arms. You must show shifts in body weight when your character is wielding a weapon or getting out of the way of someone else's. Liven things up by drawing battles from interesting directions and angles. Above all be clear and keep your compositions simple. Some compositions can be overly complex, making them hard for the reader to understand.

Showing Weight

Weapons have weight, and when a figure wields a weapon, his body should reflect that. Show the shift of weight as the swing occurs, in this case from the back of the figure to the front right side of the figure. The head has a tendency to rest wherever the balance is centered. If the head is drawn directly above the center of where the two legs are placed then the figure is well balanced. If the head rests above or close to one leg, then the weight of the figure is concentrated on that leg.

Draw Dynamic Action

More than having someone just swinging a sword, heroic fantasy is full of swashbuckling action and derring-do. Draw your character leaping in the air. Based on the velocity of the leap and the weight of the leaper this is a strategic attack against a much larger opponent.

Use References

Fill a sketchbook with drawings of people in a fencing or Kendo club. Look at the stances and postures. Note how the legs and weapons move. Pause a video or DVD during a particularly well-done battle scene, then quickly sketch the poses in each frame until you find the most dynamic way to show that action in one image. You can also learn a lot picking up a broomstick and swinging it around in your backyard. Just make sure nobody is close to you when you do it.

Aim To Please

You might not know
much about archery or
swords, but you can probably
find someone who does. Join
an archery club to get a real
sense of what it's like to draw a
bow and fire off an arrow. You could
also purchase a bow and arrow at a sport-
ing goods store and practice on your own.
Whatever you do, just be careful and respect-
ful of the weapon. Bows and arrows can be
dangerous. Your "real-life" experiences will add
a touch of realism to your fantasy drawings.

Sticks and Stones

Martial arts weapons are used differently
according to the type of martial arts the charac-
ter is doing. The traditional use of a staff in
Wushu and the traditional use of a staff in
karate are very different from each other. The
weapon should act as an extension of the
wielder. Focus on showing the weight, force
and flow of the character as the weapon is
used.

fantastic **Fashions**

Drawing elaborate clothing and armor are some of the best things about creating fantasy manga characters. Unlike some western fantasy, manga fantasy allows for a wide range of clothing and armor options. You can even disregard historical accuracy if you have a better idea for a cool image.

Bronze Age Barbarians

Barbarians were nomadic tribes that terrorized Europe in the years after the fall of Rome. Barbarians don't often wear armor and are notorious for jumping into combat wearing nothing but their tattoos and body paint. Roughly made clothing and animal fur are a sort of visual shorthand for barbarians in fantasy. Barbarians have a reputation of being hack-and-slash morons, but they actually had a rich culture and an ancient spiritual tradition of nature worship. Historical barbarians loved colorful patterns and elaborate carvings. It's time to stop the "stupid, muscle-headed barbarian" stereotype once and for all.

The March of Fashion

Clothing in medieval Europe became more complex as the centuries progressed. The first two figures from the 10th to the 12th centuries wore homespun materials with limited colors. In the 12th century the crusaders returned from the Middle East and introduced a fashion of shorter hair and clothing with brilliantly colored patterns of Eastern design. Men wore hose on their legs—not pants—and continued to wear long skirt-like tunics. In the 14th and 15th century, people wore hoods and heavier clothing because Europe endured a mini ice age. The 16th and 17th centuries saw large collars and trunk hose—a padded pair of breeches that covered the thighs. Breeches covered the leg to the knee by the 18th century and it really isn't until the mid-19th century that people wore full-length pants. Women's clothing in the 16th and 17th centuries became more elaborate with high-waisted bodices, silk ribbons and shaped sleeves.

Outfitting the Rogue

When I was developing the Rogue's costume I looked at early 19th-century working-class clothing. The shawl, that fastens in the front, was inspired by the classic Inverness sleeveless caped coat. The oversized button-down cuffs are reminiscent of some 18th- and early 19th-century military uniforms. The belts on the shins were inspired by the art and designs of Tim Burton. The split toe shoes are based upon Japanese tabi shoes traditionally worn by ninja assassins.

Emphasize the Character With Fashion

The Youthful Wizard's clothing is similar to the Rogue's outfit, but the long coat gives the impression of a cape. Mystic symbols decorate the jacket's lining to reinforce the supernatural nature of the character.

Clothes for a Pauper

The sad reality was that most of the population was poor and children more likely wore castoffs or hand-me-downs. Uneven cuts, holes and patches are all indications that the clothing is past its expiration date and the character is too poor to buy new clothes.

Design Fashions for Children

Up until the 19th century, children generally wore smaller versions of adult fashions. They didn't have a specific style or fashion that was unique to their age group.

character Design

Fantasy is the realm of the imagination, but just because it doesn't exist doesn't mean that fantasy character design should be inconsistent and random. Knowledge of historical fashion and armor technology can really help add an air of realism to your designs. Repeating shapes or motifs is another quick way of unifying a costume design. Look at clothing from other cultures and historical eras for inspiration.

This character design reinforces youth and small stature. The large weapon makes the character appear tiny. The lines of stitching are visually echoed in the checkered pattern on the sleeves and at the base of the long shirt. Repeating patterns such as the stitches and the checkers is an easy way to unify a design.

When I was designing Elf costumes I came up with this over-cloak idea that incorporated a cape-like structure with a pointed hood and mystical symbols decorating the interior of the costume. Sketching this image in my sketchbook made it easier to develop a look for the Elves.

Preliminary Sketch

The Elfin armor was a lot of fun to create. I chose a clash of long, leaf-like pointed shoulder pads to echo the ear shape and contrast with the curved spiral pattern carved on the armor. Many variations can exist until you pick one image. Compare this image to the final suit of Elfin armor. Some elements were added and others were taken away. It can take over fifteen to twenty sketches before a final design comes together. Keep your lines loose and exploratory in these early stages.

Final Design

This final design of Elfin armor has many of the elements of the initial sketch. The leg armor was simplified, as it looked too difficult to move around quickly.

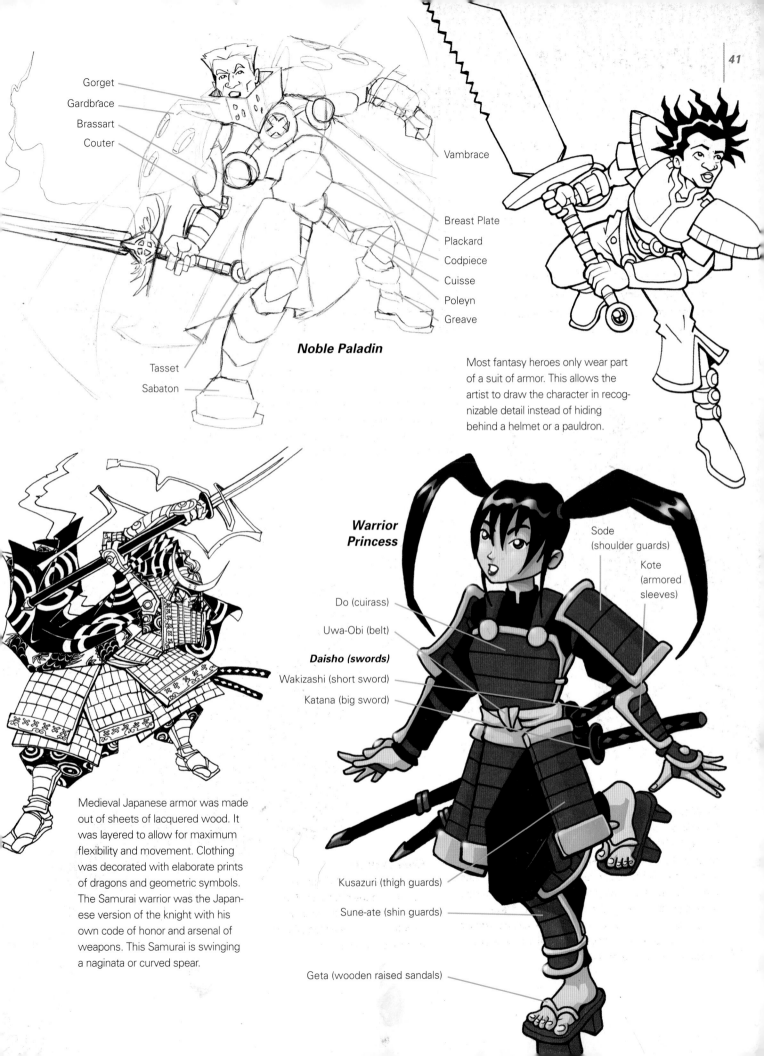

Gorget
Gardbrace
Brassart
Couter

Vambrace

Breast Plate
Plackard
Codpiece
Cuisse
Poleyn
Greave

Tasset
Sabaton

Noble Paladin

Most fantasy heroes only wear part of a suit of armor. This allows the artist to draw the character in recognizable detail instead of hiding behind a helmet or a pauldron.

Warrior Princess

Sode (shoulder guards)

Kote (armored sleeves)

Do (cuirass)

Uwa-Obi (belt)

Daisho (swords)

Wakizashi (short sword)

Katana (big sword)

Kusazuri (thigh guards)

Sune-ate (shin guards)

Geta (wooden raised sandals)

Medieval Japanese armor was made out of sheets of lacquered wood. It was layered to allow for maximum flexibility and movement. Clothing was decorated with elaborate prints of dragons and geometric symbols. The Samurai warrior was the Japanese version of the knight with his own code of honor and arsenal of weapons. This Samurai is swinging a naginata or curved spear.

Headgear

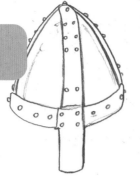
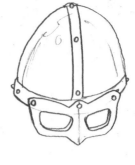
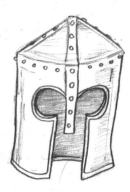

Protecting the head is an important function of armor, yet in manga and anime the face of the character is often exposed to let the reader easily identify the protagonist of the story. Face-covering helmets are usually reserved for the faceless minions of the evil overlord.

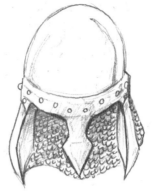
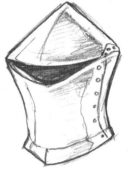
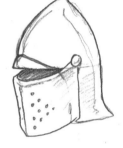

Helmets come in many shapes and sizes. Wearers of helmets would usually wear chainmail over padding underneath. Some had chainmail attached to them and later models had visors that could be lowered when danger approached. Helmets are one of the few items of armor still worn today by the modern military.

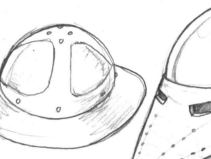
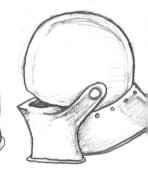

Donning a Helmet

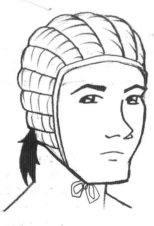
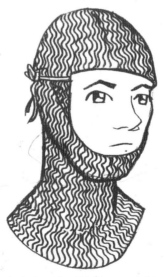
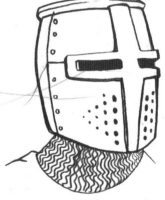

1 A padded hood is worn first. This helps absorb any impacts from falling or weapons such as maces or clubs.

2 A chainmail coif is worn over the padded hood. Chainmail is much too heavy to be worn without padding for long periods of time. Chainmail provides excellent defense against cutting weapons, but is useless against blunt weapons because the chains dig into the skin when hit.

3 The "bucket helmet" is strong and simple. It is still vulnerable to some chopping attacks and most blunt attacks. As you can well imagine, it's difficult to see what's going on through that tiny slit, but you are better protected with a full-face helmet.

Weapons

*T*raditional medieval weapons inspired manga fantasy weapons, but manga weapons are often larger and more ornate than their real-world counterparts. Let's cover the basics.

Bashing Weapons

Daggers and Knives
The oldest daggers were made of stone and flint from about the time of the Stone Age to the beginning of the Bronze Age in Europe.

Scimitars and Glaives
Scimitars are wide chopping swords that originated in the Middle East. Glaives are a form of pole arm that has a large blade on a handle. They are basically used for chopping and thrusting at a distance.

Swords
The end of the grip is fitted with a "pommel." This acts as a counter-weight to balance the sword as it is held.

Types of Swords

Rapier

Chopping Sword

Knights' Sword

Hafted Weapons
These weapons are placed on the end of wooden or metal handles. They allow the wielder to fight from a safer distance and some, like the spear, can even be thrown at targets.

Crossbow
The crossbow was a bow mounted to a stock. A trigger mechanism on the bottom released the string and launched the arrow, or "quarrel."

Bows and Arrows
Bows and arrows are traditional fantasy ranged weapons. The Longbow is a difficult weapon to master and even harder to maintain so few countries adopted it as an official military weapon.

youthful Adventurer

Young and curious, the Youthful Adventurer is most often the main character of the fantasy adventure story. He usually has an unusual birth or origin and has some power or ability that will help him win in the end. Typically he is unwittingly thrown into an adventure guided by a mentor and aided by companions who compliment his skills and character—and also provide comic relief. The hero sets out for adventure in a world that seems alien and menacing. Eventually he is captured, overwhelmed or surrounded and must endure a series of tests in order to confront the final challenge (symbolically a dragon). He then fights a horrible battle and has a near-death experience, but the hero ultimately uses his powers to win the day in a magical chase or flight, and he successfully completes the quest. Returning home, the hero has become stronger by his adventure and is duly rewarded for his efforts.

1 Ask any manga villain: Heroes just don't stand still. His hero is on the move. Ensure that the sword appears to have some weight in the hero's hands. The head leans forward to show the momentum of the movement, but also to counterbalance the weight of the sword. Keep the initial lines simple and clean. Too many lines can become distracting and may be difficult to erase later.

2 Block in the details of the figure, such as hands, costume and facial features, correcting the stance as you go. The hero's youth is reinforced by the fact that he is not too bulky.

3 Erase the initial lines and reinforce the outlines of the form. Elements of the character's personality begin to show through when you draw his expression, hairstyle and clothing.

4 The final inks really clean up the forms. Erase the underlying pencils only after the ink is dry or there will be lots of smudging. Remember to vary the thickness of the line to reinforce form and weight. Solid areas of black are very strong focal points in the drawing.

5 Add the final details when you color and add the 3-D shading. Pitted armor and weapons add a sense of realism to the image. Make sure your light source is consistent for shadows and highlights. Use photo references; manga style may not be realistic, but that doesn't mean you can just make up details like light direction, shadows and highlights. Use every tool and technique you can to make your image convincing.

Our Hero

The fantasy manga hero doesn't always have to be young and male. Part of understanding the elements of the fantasy genre and the story archetypes means that you can then have fun subverting people's expectations. Don't be content to tell the same story over and over. What if the hero isn't very heroic after all and it is up to the damsel in distress or the stereotypical villain to save the day? When you fiddle with the building blocks you can create something interesting and original.

princess Warrior

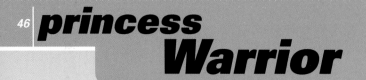

The Princess Warrior has much in common with the Youthful Adventurer, but she often has the added burden of dealing with the prejudices of her culture, which underestimates her abilities because she is female. Once she overcomes this prejudice she usually has the same kinds of adventures as the male heroes. The Princess Warrior often has some magical item that allows her to transform into a more powerful form. Manga and anime have a long tradition of strong Princess Warrior characters who embark on epic quests and gain fantastic abilities to defeat overwhelming adversaries.

1 Block in the basic pose quickly and loosely. Draw her holding the weapon so it appears to have some actual weight, but is balanced and controlled. At this stage you are just planning where things are going, but notice how the head is centered for maximum stability.

2 Add details to flesh out the stick figure. The weapons and armor are based upon Japanese samurai equipment. At this stage make sure you are checking your anatomy and proportions in case you have made any errors. Draw lightly; you will erase these construction lines in your final drawing.

3 Clean up the underlying sketch lines. This helps focus the details of the armor and weaponry. The chain is particularly troublesome. Take your time and try looking at real chains for reference. Don't worry if you can still see through some parts of the drawing where things are overlapped; you won't see these in the final image. Drawing through helps maintain precise proportions, anatomy and a sense of structural form.

4 Clean up your construction lines and ink them. Carefully develop the details with the ink and eliminate all pencil lines. You can use a light table and ink over your original artwork on a separate sheet of paper. Flat areas of black are broken up with highlights (on the hair) and outlines where two areas of black overlap (on the clothing).

5 The colors and shading are bold and primary. The armor is made of red lacquered wood with details highlighted with gold leaf. She is a princess after all. Just remember to keep the light source consistent as you shade your image.

Part of the Team

The Princess Warrior is part of the classic "five team unit" popular in classic anime and manga television shows. The team is usually headed by the Youthful Adventurer and made up of the Princess Warrior, Rebellious Hero, Kid/Comic Relief and the Big Lug. Very often the Princess Warrior is the sister of the Adventurer or the Kid.

youthful Wizard

Magic is the key element of a good fantasy story. The Youthful Wizard discovers he can control powers beyond his imagination, but he is usually too inexperienced to use his powers properly. Under the guidance of a mentor or guide, he learns to control the power and use his abilities for good. Easier and more impressive magic is possible, but without the discipline and hard work provided by the mentor or guide, the hero could be lured into using evil magic that can corrupt the hero and turn him into a villain. Indeed, the Youthful Wizard has some difficult choices to make as he becomes more and more powerful. Twisting the fabric of reality has its cost and madness awaits those who misuse the awesome forces of magic.

1 Sketch in the forms using the basics of construction drawing and human proportion as a guide. Notice how the spine curves back to accommodate the weight of the creature on his arm and how his head arches forward off of his chest. Remember, the figure exists in 3-D space so don't draw him in a flat pose.

2 Flesh out the details as you go. The preliminary drawing will help you with the placement, but practice and observation will assist you in getting the details to look right. Notice how some elements are drawn through so you can see the shape of the clothing or limbs behind other objects. This is an important technique at this stage because it helps you accurately place items on the figure in relation to one another.

3 Carefully clean up the linework and focus on what accurately describes the form. This step simplifies the image from the tangle of extra lines used for lining up the drawing. Keep it simple at this stage and add details later.

4 Carefully ink over the existing pencil lines and add texture, weight and pattern on the drawing. Make sure that patterns, such as the spirals on the wand and the rings on the tail, help reinforce the roundness or general form of the object upon which they are drawn. Very often patterns can flatten the image unless they wrap around the forms on which they are applied.

5 Coloring and shading presents a whole new host of problems for you to solve. Never "color in" the image. Use color and shading to make the image appear 3-D. Cel shading can be a little harsh, but it is a simple and effective way to mimic the look of anime and manga. Softer use of computer shading, markers, colored pencil, or paint still requires the artist to think of the legs as cylinders and the shadows and highlights on the final image. Use photo references for shading that will let you see the relationships of light and dark on the figure.

Fantasy Magic

Magic in fantasy manga is dynamic and dramatic. Effects are flashy and powerful, often destroying sections of entire towns with one blast of energy. The wizard often pays for this use of supernatural power by losing part of what makes him or her "human." The dark magic is easier and more powerful with less apparent sacrifice, but it sucks the soul away and can turn the Wizard into something much darker and scarier than the monsters the characters meet. In anime and manga, magic is often a flashy special effect that requires much yelling, arm waving and dramatic transformation sequences with lots of sparkles and bolts of lightning.

noble Paladin

Called by a divine presence to don armor and battle evil, the Noble Paladin often wanders the land doing good deeds and defending the weak. Unlike the Youthful Hero, the Noble Paladin understands his quest and has the equipment and training to get the job done. Shining and golden, he faces insurmountable odds and overcomes them with an effective combination of faith, ability and powerful relics and equipment. The Noble Paladin's main problem is his tunnel vision and inability to stray from his goal. He is willing to sacrifice himself for the greater good and it is that fearlessness and selfless-ness that often turns the tide of battle when his allies become inspired to leap to his aid.

1 Break down the complexity of the pose and armor into a simple ball and stick gesture study. Make lots of these studies in your sketchbook from photo-graphs and posing friends. Once you have the biomechanics of the human form mem-orized you can draw the character from your memory. The head usually rests over the area of weight distribution. The weight of this character is clearly over his right leg.

2 Block in the elements of the figure and the costume. Refer to refer-ences for convincing armor construction and detailing.

3 Clean up the details as you add more information in the drawing. Erase some of the original pencil lines and reinforce the final lines as you go. The character's attitude begins to emerge now. Make sure the Noble Paladin appears strong and confident. If he plunges headlong against the forces of evil, he'd better be tough.

3

4 Line width should reinforce the weight and form of the objects you are drawing. Thick lines appear heavier and more in shadow. Thin lines recede and are appropriate for areas of highlighting.

5 Color and shading will reveal even more about the forms you are drawing. The blue cape is a symbol of spiritual nobility and the shining golden armor adds a sense of magic and glamour. This is the archetypical knight in shining armor.

The Ultimate Quest

The Noble Paladin is a knight devoted to the ideals of spiritual belief. He seeks out evil and destroys it. He is a knight devoted to chivalry and heroism. Divine inspiration has been the spark of many magical quests from King Arthur and the Knights of the Round Table to Charlemagne and his Paladins.

lovable Rogue

The Rogue is a sneaky character who is often a thief or spy. The hero often meets the Rogue after something has been stolen from the hero or his friends. The Rogue then joins the adventure only for profit, but soon becomes caught up in the spirit of the quest and shows an unexpectedly gallant and dignified nature. The Rogue often saves the day in the end, distracting the villain or rescuing the hero at the last moment when everyone thought she had long disappeared into the shadows. The Rogue also has the best wisecracks in the story, being a cynical character who has been around a bit and thinks she knows a thing or two about how the world works.

1 Keep the pose sneaky. Moving the body weight to one side keeps the viewer wondering what the character is going to do next. I chose to make this character long and lean, very fox- or cat-like. Those lines on top of the head are there to block in her crazy hair.

2 Build up the structure of the figure over the initial gesture lines. Give her hair volume. Draw her ears slightly pointed, indicating that she is half human, half elf. Some elements of the costume, such as the belts on the shins, are more about defining the rounded shape of the leg than actually serving a practical function. Also it just looks cool.

3 Erase the construction lines or trace the image onto another sheet of paper. Develop the details of the clothing. Details really help define the character. Ninja warriors in Japan used the split toe slippers or "tabi" shoes. Reinforce the character's nature by providing sneaky, sure-footed footwear.

4 Carefully erase the guidelines and clean up the quality of the lines in your finished drawing. Attention to details like the buttons and buckles helps convince viewers that what they are seeing is "real."

5 Colors for the Rogue should be dark and muted, allowing for easy lurking and general sneaking around. The costume should also be simple and easy to move around in. Rogues don't usually carry huge weapons. They usually run from a fight or if they must fight, they fight on their own terms.

Gray Area

The Lovable Rogue is a good example of how someone who appears to be breaking the rules (or the law) can become a folk hero and redeem himself by doing good deeds or using his "special skills" for a good cause. Famous outlaws such as Robin Hood or the Scarlet Pimpernel can get jobs done that the average knight in shining armor would never dream of doing. Need a dragon slain? Call a knight. Need a dragon's treasure? Call a rogue.

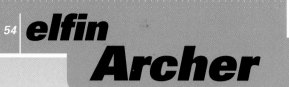

elfin Archer

The Elf is a fantasy archetype that has translated very well into manga fantasy. Elves are the physical embodiment of the spirit of nature in the world, which is a common element in anime and manga. They are often the conscience and the heart of the heroic struggle against destructive forces of evil. Elves are powerful mages who can control natural energy. They can even communicate with elements of nature such as the spirits of the trees, hills and streams.

1 The Elf is light-footed and has fluid, sweeping movements. Some legends even claim that the Elf is so in tune with her environment that she doesn't even leave footprints. Keep things simple to start, realizing that you will add details soon.

2 Keep a sense of the 3-D forms: cylinders for the legs and arms and spheres for the head, torso and hips. The legs shouldn't be lined up flat—show some depth! Draw the leg closest to the viewer lower than the leg further away.

3 Erase your rough construction lines and darken the final figure lines. Add details such as the tattoos or war paint on the face; they give the Elf a more feral, primal look. The bow and arrow quiver was inspired by representations of Mongolian archers of the 14th century. The pointed boots are a nod to traditional fairy-tale depictions of Elves.

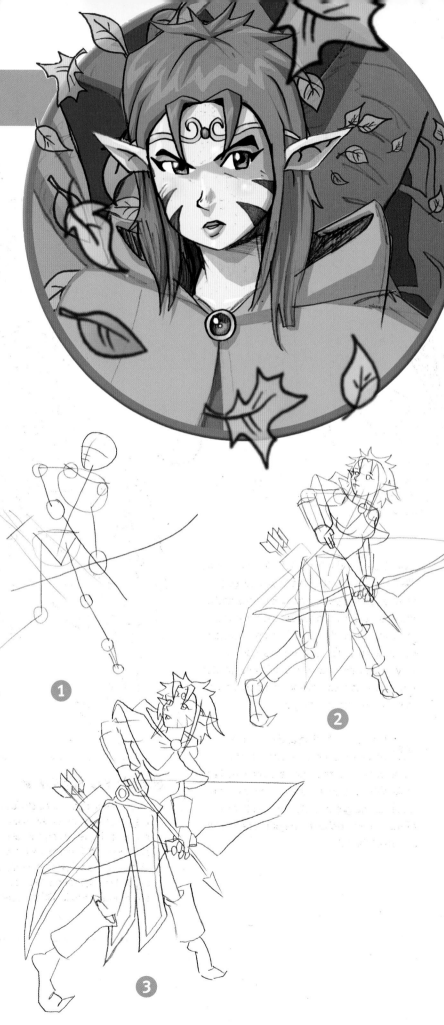

4 Clean up the lines. Add details such as the spiral pattern on the clothing. The stitches on the pants and wristbands add a touch of realism and relates the image to other images in the book. The spiral pattern could be a mystic symbol in this world, a way of focusing magic power. For the reader, the symbol is a sort of shorthand message that this character is magical.

5 The act of shading and coloring the image requires the artist to make some very important choices. The blue hair makes the character appear more exotic or magical. The green and brown earth tones of the clothing echo the natural forest spirit nature of the Elf.

Back to Nature

Many anime and manga stories explore the theme of environmentalism and the role of humanity in preserving and taking care of the natural world. Despite the fancy robots, spaceships and martial arts mayhem, the main message of manga seems to be to take care of the environment and it will take care of you. Good advice.

bounty Hunter

He's big, he's bulky and he's looking for the bad guys because that's his job. The Bounty Hunter is a big guy doing a big job. He is a mercenary, working for the king one week and the evil prince the next. The main characters of the story usually win him over by offering promises of riches, sometimes even paying him more than his boss to disregard an order or undertake new orders. The big guy is rather soft-hearted too and can sometimes be talked out of a job with an appropriate sob story. What a pushover.

1 He's too big to draw on the page? No, he's just leaping with his weapon to chop some unsuspecting bad guy in two, or at least scare him. Bounty Hunters aren't known for their subtlety or good manners. They often slash first and ask questions later. The pose is dynamic and full of action. This big guy is in mid flight!

2 There should be more muscle than flab on this guy. Draw him like someone who can capture even the toughest hombre and win the reward. His sword is huge and even though he's built to bench press an Ogre, he should only just be able to wield it. He is dressed like a pirate or a barbarian, keeping things simple as he travels from town to town in search of his bounties.

3 Block in the details over the under drawing. Erase extra lines and only save the lines that best describe the form. Too many lines will make the drawing appear sketchy and unsure. If your rough work is too dark to erase or you want to keep the illustration fresh, trace the image onto a fresh sheet of paper.

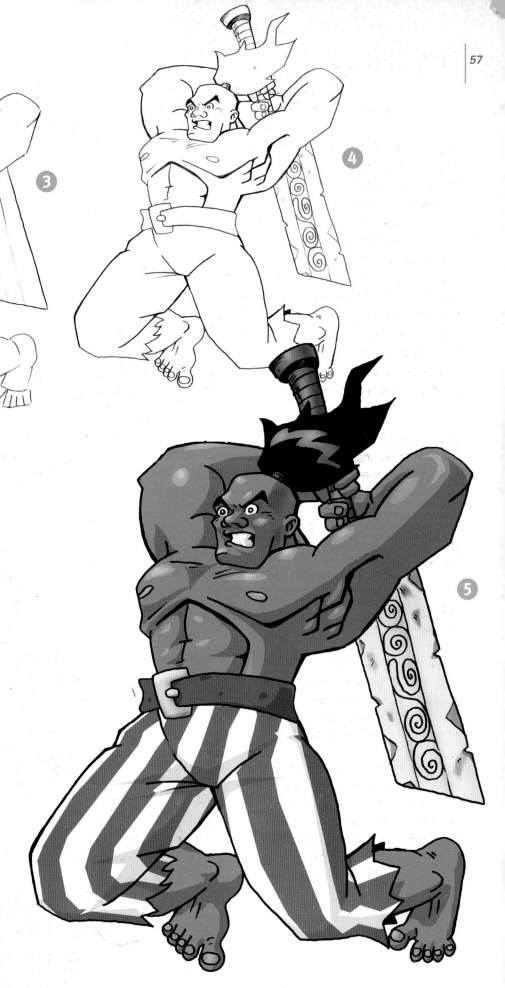

4 Clean up the rest of the lines and pay attention to details such as his ribs, muscles and his sword. The little x in his hair indicates that the final image will be colored in black later.

5 The striped pants echo his pirate look and create a bold, graphic image. Make sure that your figure is rounded and shaded in a convincing way. Don't forget about the highlight in his hair. Pay attention to the folds and creases of his pants as well as the distressed surface of his humongous sword.

The Big Lug

The Big Lug is a manga and anime classic. Most often this guy terrifies everyone with his hulking presence and frying-pan hands, but turns out to be a real softie, crying when one of his pet Blood Dingos dies. Alternately the Big Lug is a country bumpkin or simpleton who just happens to be really clever with mechanics/languages/computers/insert technical skill here.

trusty Dwarf Warrior

Dwarves are everyone's favorite fantasy characters. They are clever and hard-working, and sing about glorious battles and hard-won gold. They are earthy and trustworthy, real salt-of-the-earth types, which is funny because they usually live underground. They are about 4 to 5 feet tall (122cm to 153cm), powerfully built and stocky.

1 Block in a short, stocky form with a powerful frame. Draw through to show the forms of the figure even if they are hidden and overlapped by other forms. This avoids accidental distortion when drawing. Planning at this stage lets you draw what you want where you want on a page. Know the extent of the image before you start your good copy so you avoid false starts.

2 I researched the details of the weapon, clothing and armor and carefully applied them to the character. Other Dwarves will wear similar armor and carry similar weapons, but it's a good idea to vary their appearance or else all your Dwarves will look the same. After you have finished the details in ink and let the ink dry, erase the underlying pencil work and move on to shading and coloring.

3 Make the colors bold and deep, with a wide range of light and dark to show 3-D form on the figure. Highlights enhance the reflective surfaces of hair and skin. Vary the gray you use, warm grays for the fur and cool grays for the metal.

dwarf Alchemist

Alchemists are the fantasy steam-punk manga's version of the inventor. They create weapons and equipment that are centuries before their time, such as flying machines, clockwork men and heat ray guns. Dwarves have less luck with magic but are technical minded, so their "magic" is often tied up into chemicals, engineering and mapmaking. This inventor has created a steam-driven dart gun that is powered by a glowing red liquid; perhaps it's dragon blood? She also has a wrench to fix whatever might fall apart.

1 Block things in quickly. Even complicated objects like the dart gun can be broken down into basic forms. It's tricky to make Dwarves appear stocky and not just out of proportion. The hands and feet are usually exaggerated and drawn in a chunky, coarse way.

2 Keep thinking of how things work and the details will come easily. For example, the plate just below her neck is part of the apparatus that attaches to her shoulder pads and holds up her cape. Have fun designing the dart gun. A glowing liquid fuels an engine that turns the wheels and fires the darts out of the gun.

3 Folds and creases in clothing and metal help define the character. The metal is shaded in a soft way with strong highlights and shadows. This makes the metal appear more metallic. The highlights on the cape give it some form and make the figure appear less flat.

Barbarian

Fantasy stories are foul with barbarians stomping off to chop apart some unlucky monsters. Barbarians are stereotypically hulking men with huge muscles and loincloths so having a female Barbarian helps shatter some of the boring expectations of the archetype. We have given her a large sabertooth tiger as a pet and a huge sword to drag from adventure to adventure.

1 Quickly block in the basics of the figure, including the wild ponytails and huge sword. The tiger is really another character in the lesson; he's just lying down at the moment. What mischief could these two get into?

2 Although not historically accurate, Barbarian clothing is usually in pretty rough shape, often torn, hanging, or poorly mended. The hairy leggings (I hope they are leggings!) show that she is often tromping through deep snow battling monsters. Little details such as the snake armband and the skull-shaped hair adornment give her attitude.

3 In addition to the jewelry and hairstyles, add blue paint or tattoos for a more tribal look. The cool colors of her hair and pale skin make her seem at home in an icy wasteland. Shade and highlight the figure to ensure that she appears 3-D.

sword Master

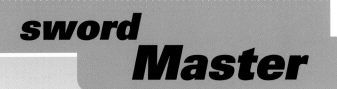

Fighting with two swords is very tricky. Fighting with two huge broadswords is impossible! Fantasy has fun with reality and lets humans do superhuman things from time to time.

1 Sketch the figure leaning far forward because of the weight of the mammoth swords he is swinging. His legs are wide as he struggles to remain upright. Realistic or not, he's going to chop something in half with those bad boys.

2 Finalize the lines. The spiral bracers show that he may have some connection to the Elves or magic. Make the hair and sideburns look out of control and streamlined to echo the sharp lines of the weapons and the fur on the boots.

3 The tattoos connect the Swordsman with the Barbarian. Other connections, such as the hair color and the clothing style and color, help establish a relationship between the two visually, even before you know anything about them.

Necromancer

A Necromancer is a type of dark wizard who gets his magic from death and creates undead creatures such as zombies, walking skeletons and liches. Necromancers make great villains because they can launch horde against horde of horrifying monsters after the hero and use their magic to come back again and again.

1 Keep it simple as you block things out. He is holding the staff in front of him and his body is coiled like a serpent. Avoid drawing sausage-armed characters; instead draw tubes and spheres. At this stage what you draw should be considered 3-D forms existing in space.

2 Clean up the lines and add some details. Pay attention to the proportions, remembering that the figure should appear emaciated—almost a skeleton. This is the stage where you can have the most fun playing with costuming and details like the skull on the staff, the horned hat and the big rock-'n-roll boots.

3 The colors should be subdued. Add stains and splotches to the costume so it looks like he has been digging around in the catacombs for quite a while.

wicked **Witch**

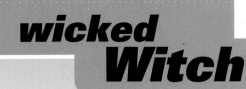

She sits at the top of a dark tower surrounded by her evil minions, and glares into a cauldron scrying the future or at least checking out what trouble those heroes are up to now. The Wicked Witch uses her magic powers to try to stop the heroes from achieving their goal. She rarely ventures out to battle them unless she is in disguise and then only when her dark minions fail. It's so hard to find good help these days.

1 The figure should appear regal and tall, almost hovering over the ground even though she is planted firmly on the floor. The base of the dress flows out in long strips like an octopus tentacles. Sketch in elements of the costume and details like the writhing magic ball and the evil cat-monkey at her feet.

2 Begin to develop the details in an organized way, inking carefully over the original pencils. The wing-like cape and oversized collar make her appear sinisterly like a bat. After carefully inking everything, let the ink dry and then use the eraser to remove the pencil lines.

3 Keep the cat-monkey dark because it is a creature of shadow, a naughty little imp looking for mischief. The costume is fairly simple and not very colorful or flamboyant. The stripes on the sleeves help break up the monotony while adding some interest to an otherwise plain design.

Cat Girl

Hey, it's manga and it's fantasy manga so there's got to be a Cat Girl. Cat Girls work in fantasy, modern, historical and science-fiction settings. They are just so darn cute.

1 Carefully block in the figure. This helps you plan the look of the finished drawing and compose the placement of the figure on the page. Start drawing basic forms and lines, then gradually flesh out the skeleton until the figure takes shape.

2 Clean up the linework, inking the final lines with lines that alternate from thick to thin. Thicker lines will appear closer and seem to have more weight. Thin lines will recede and appear more as highlights. Take care when you are erasing the pencil lines; ink can get smudgy if it isn't dry yet.

3 Remember, the figure is 3-D, not flat, so carefully depict the areas of light and shadow. Pick fun and bright colors for the Cat Girl. You may want to look at patterns on real cats to get ideas on how to color the character.

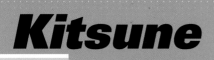

Kitsune

The Kitsune is a shape-shifting fox from Japanese folklore. It usually takes the form of a pretty human girl and bewitches men causing all kinds of mischief. In the land of the Kingdoms, the Kitsune is a species of enchanted fox people who traveled west with the Cathasians when the forces of Chaos tore apart the lands of the east. It can still take the form of a human but it prefers the middle state, a human/fox hybrid. Kitsune can live for thousands of years and gain a tail for every thousand years they live. The most magical Kitsune have silver fur instead of orange fur. Watch out for them!

1 Block in the forms of a figure sitting down. The most prominent features are the large head and ears and the big bushy tail. Quickly block in the shapes of the bowl and shoes.

2 The details of the clothing, the geta sandals, the fox attributes, and the bowl of rice all took some research before I could confidently draw them at this level. The line thickness ranges from thick to thin in an effort to describe the form and weight of the figure. Spots of black on the ears and tail really stand out at this stage.

3 So this is a silver Kitsune; the color is a sign of great power and great age. The clothing is bright yellow with an orange obi (belt). This Kitsune is mischievous, but he's not trying to hide; he's looking for trouble and is starting out by stealing a lovely bowl of rice. Make sure that the light source makes sense. Carefully place areas of shadow and highlight to help define the form of the figure.

monkey Fighter

The Monkey Fighter is an ancient character in Chinese mythology. Originally documented in The Monkey King, a Chinese novel written by Cheng-en Wu in the sixteenth century, the Monkey was depicted as a trickster character that used magic and martial arts as he travels around the world on many adventures. The Monkey Fighter is a similarly tricky character that acts as an enchanted guardian of jungle temples on the Vistiran Islands.

1 Start with the basic circles and tubes. The proportions should be rather inhuman—give him large feet with opposable toes and a long, curling tail. Flesh out the figure, carefully adding some details as you go.

2 Clean up the pencil lines and ink over the drawing. The solid black fur gives the monkey a strong graphic presence. Notice how highlights on the fur help define areas where the dark fur overlaps another area of dark fur. This is needed to define the form or else it would be difficult to tell where the arm bent or the leg twisted. Erase extra pencil lines.

3 Color and shading breathes life into the final drawing. Use the highlights in the eye as a guide to show the direction of the light falling on the figure. Notice how the wooden texture on the hat and the armor adds to the realism of the image even though it is wonderfully cartoony.

Lizard creature

The Lizard Creature can range in size from 4 feet to 10 feet (122cm to 305cm) tall. It is a strong hunter and can be found throughout the kingdoms in deserts and rainforests. Lizard Creatures have wicked claws and a relentless predatory attitude toward the world. If they want something, they just take it.

1 Block in the basic forms. Tilt the figure somewhat so it is on a dynamic diagonal, not a straight line.

2 Carefully use ink to finish the details of the drawing. Clean up the extra lines and erase the pencil lines. Remember to vary the thicknesses of the ink line.

3 Before the drawing is finished look at areas of texture that can be developed, such as the scales. Every surface will have its very own problem to solve whether it is the reflective helmet or the smooth, rounded claws. The drawing should appear 3-D.

pirate Captain

One of the appeals of the fantasy genre is the ability to draw elements from various historical eras and combine them into one setting or story. Pirates and their swashbuckling fencing are a wonderful contrast to the traditional swords and sorcery dungeon lore.

1 He's bold, he's dynamic, and he should be standing like he's about to jump into action. It's a good idea to experiment with various poses in this stage to get a handle on the attitude and physical presence of the character. Roughly block in costume and anatomical details at this stage.

2 Clean up the pencil lines and carefully apply ink to define the forms and show areas of shadow. Add details like the skull on the hat and the buttons on the jacket. Inject a sense of realism and personality to the drawing.

3 The Pirate Captain doesn't have anything to hide, so his color scheme is bright and bold. Consistently develop areas of highlight and shadow with a main light source in mind. Notice how the darkest area of shadow on the clothing is in the back of the coat.

pirate Thug

What good would a Pirate Captain be without a ship full of thugs? Pirate Thugs come in all shapes and sizes and are drawn from the multitude of cultures and species throughout the known world (even some from the unknown world). Historical pirates were surprisingly democratic and fair in making decisions and sharing treasure.

1 Keep it simple as you block out the image. Slightly exaggerate the proportions for comedic effect. Have fun with the characters you draw. Minor manga villains are often suitable targets for the hero's awesome fighting or magic skills and for overall comic relief.

2 Adding the hole in the money bag and the falling coins helps explain the look of dismay on his face. Vary the thickness of your lines to help define the 3-D form and shadow. Carefully erase the pencil lines without smudging the overlying ink.

3 Color and shade with a sense of cast shadows and highlights. Pirates traditionally wear what clothing they can steal. The British navy didn't really have an official uniform for their sailors until the mid eighteenth century so sailors wore traditional working clothes. The "used" look of the clothes reinforces how they worked, slept, fought and swam in the same clothes for months at a time.

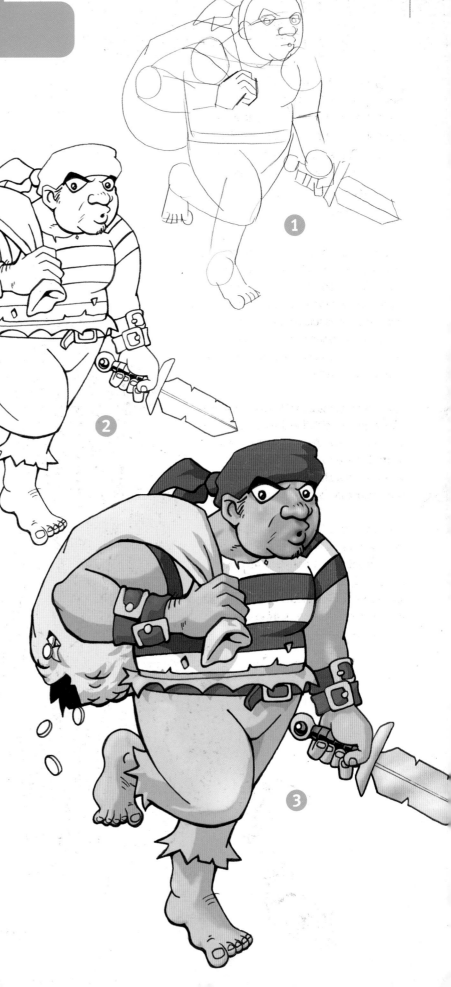

Ogre

*I*n the world of the Kingdoms, the Ogre is a demonic creature born of chaos magic from an ancient time of sorcerer kings. Ogres have huge claws which they use to tear apart their prey. They are always hungry and are motivated by promises of lots of food. Ogres are cruel and stupid creatures who can be easily tricked. They often gather huge armies of Goblyns to pillage and terrorize the countryside. The Ogre is the alternate guardian or opponent in some myths. Variations of the Ogre include the one-eyed Cyclops of Greek mythology, the Japanese Oni, the Stone Giants of native North American legend, and the biblical Goliath.

1 Start by blocking in the basic structure of the figure. Emphasize the powerful claws so you remember to develop them later. Think of the 3-D forms of cylinders, spheres and prisms as you are planning your image.

2 Add mass and detail to your drawing. The horns and claws provide a feral, demonic appearance. The simple loincloth reflects the Ogre's technological and cultural level. Draw lightly in these early stages so you can lift the pencil lines when you apply the ink.

3 Define the details and remember to establish the anatomy using a clear sense of space and structure established by the basic shapes you drew in step one. The forms should appear 3-D. The basic running pose is more complex because of the hunched shoulders and the head overlapping the torso. Erase underlying pencil work as you go to avoid confusion.

④ Carefully redraw the image using ink; leave out the initial guidelines and extra construction lines. Vary the line width from thick to thin to show areas of shadow and mass. Thick lines will appear to come forward and thin lines will appear to recede. Move the pen in the same direction that the hair would grow, as indicated by the highlights in the arm hair and beard. This is a little detail, but it is very important for convincing the viewer that the forms are 3-D.

⑤ Use earthy and natural colors. Anything too bright would be uncharacteristic for this kind of fiend. Small details help the monster seem more monstrous. The teeth, horns and claws are a nasty yellowed beige, never white. Make sure that the light appears to fall across the surface of the creature. Areas of shadow should appear on the figure in the opposite direction of the light source.

Ogres Terrorize the World

The word ogre is derived from an ancient Sanskrit word "ugra," meaning violent. In any culture, the Ogre is a symbol of a great evil that must be conquered by the hero, usually through trickery.

- Mongol Ogres are usually female and fond of drinking human blood.
- Japanese Ogres are called Oni and are considered demons or symbols of the evils of the world. They are usually depicted as giant horned humans wearing animal skins.
- African folktales describe Ogres as horrifying giants that can devour entire villages. In one Kenyan story, a boy cuts off the toe of an Ogre and the villagers eat it.

Horse

The Horse is the standard mode of transportation in a fantasy setting. A knight on horseback is an impressive opponent. Horses can knock people on the ground and out of the way and can travel great distances quickly. They were the key to the rise in power of the chivalric knight class in Europe in the early middle ages.

1 Drawing quadrupeds (animals with four feet) can be quite a challenge. It always helps to get a few images of horses to help with anatomy issues. Block in the structure using standard circles and tubes.

2 Add important details such as the hair on the mane and tail, the riding gear and the saddle. Carefully ink the drawing and erase the construction lines. The little x in the middle of the back leg is a shorthand message that it will be inked in black.

3 The light and shadows should appear to wrap around the forms of the horse. This is a difficult figure to shade properly. It might be helpful to pick up a few toy horses to use as models for your drawings. Cel shading uses simplified areas of highlight, middle range and shadow. Be careful as this style can make the image appear flat. Be consistent with your shading and make sure the main light source appears to be in one place. Add realistic details like the smooth highlights and shadows on the hooves.

Spirit

Spirits aren't necessarily ghost; they can also represent the forces of nature. Some are good and some are bad. Japanese nature spirits are called Kami. Spirits can be helpful, mischievous, or hostile; it just depends on how much respect is shown to them.

1 Quickly block in the Spirit. It is drawn with a humanoid torso so the expressions are familiar to the reader. Lines of wispy air rise off the figure to show its incorporeal nature.

2 The image is simple and dynamic. Clean up any confusing lines and ink the drawing. Areas that are thicker or darker will be focus points. Draw the eyes with a heavier line so they become the center of attention of the figure.

3 The heavy lines have been drawn blue. This can be done with blue ink or digitally as in this case. The blue helps knock down the contrast on the image and makes it appear lighter and softer, more like an air spirit. If this figure were done in reds, oranges and yellows it would be a good fire elemental.

corrupt Noble

Bad guys come in all shapes and sizes. The Corrupt Noble is powerful because rules over an army of thugs and often has control of the strongest castles in the land. Many people listen to the Corrupt Noble because he has somehow gained power and traces his lineage to the royal family. If he isn't stopped he may try to take over the whole kingdom!

1 Quickly block in the figure and details. The perspective is from above, focusing on the blade he is holding. Keep things loose at this point and avoid making lots of scratchy lines that can confuse the inking later. Keep your construction drawing clean and confident.

2 Ink the image and erase the rough pencil lines. Details such as the bird crest on his chest and the pointed dagging (decorative edges) on his surcoat (long tunic worn over armor) provide elements that quickly identify and define the character.

3 Choose dark colors so he appears somewhat sinister. The crystal dagger he holds could be the item of power he uses to control his people or it could be the prize in a contest designed to trap the hero. Add details of the armor. Use highlights and shading to reinforce his form. Also use shading to define the anatomical details such as the cheekbones, rib cage, and chest muscles. Make sure he looks mean.

mindless Guard

The Mindless Guard is actually one of a whole army of inept opponents who find themselves pitched against the superior forces of the heroes. Sometimes there are variations of the Mindless Guard; there may be a pair of guards, one short and rounded and the other tall and skinny; another might be sympathetic to the heroes and secretly help them out. The Mindless Guards frequently have very capable armor and weaponry, but even so they typically fall with one strike.

1 The pose is a little more dynamic than usual. The Guard appears to be bracing himself for combat. Block in the stick figure, then thicken it up using tubes and other 3-D forms. Draw the preliminary costume and equipment shapes.

2 Ink the figure and clean up the pencil lines to give him some character. Little touches such as the dented shield and dinged-up sword provide a sense of realism in your drawings. The stylized bird symbol on his chest links him to the Corrupt Noble.

3 Pay attention to light sources so you can put shadows and highlights in the right place. I choose one direction of the drawing (usually determined by the highlights in the eyes) as the location of the light source and then make sure everything else in the drawing relates to that. For added realism and a wider gray scale, place a realistic wood grain in the shield and smoothly shade the metal of the sword and helmet.

King

The King is a fearless leader who pronounces royal decrees and sends heroes off to battle powerful evils that threaten the kingdom. In many manga and anime, the King is a stoic leader who is strong, silent and wise.

1 Even though you won't see the legs in the final drawing, it's still a good idea to block them in at this stage so you can make sure you have consistent proportions. Roughly block in details as if they were transparent. This ensures that the structure is correct before you continue. Anatomical elements impact folds and creases in clothing that appear in the final drawing.

2 The robes are loose and flowing, bunched up, and folded and creased here and there. The underlying drawing will help determine where these areas are, but so will careful observation of folds in material. Wrap someone up in a sheet to see how folds and creases appear in relation to the underlying forms and the pull of gravity. Ink the lines, then erase the pencil lines. Add details such as the crown, cup and fur lining to give the character some life.

3 Keep the light and dark consistent, reflecting the form of the figure as well as the shadows cast by other elements such as arms and coats. Smoother shading on the metal makes it appear more reflective and realistic.

Princess

She may be small, but she's got a lot of power and attitude. The Princess is accustomed to getting what she wants. Some people might call her a spoiled brat, but they usually end up in the dungeon. This is a classic fairy-tale princess complete with pointy hat and flowing dress, but she also has a lot of attitude. If the bad guys capture her she often complains so much that they are happy when she is rescued.

1 Draw simple forms to help create complex images later. Draw in the legs even though the gown hides them. Block in the entire figure to avoid distorting her. Also block in the cat creature using simple forms. The foot and arm that appear to be coming towards us will hide some of the figure, but are drawn transparent at this stage.

2 Clean up the rough pencil lines and ink the image as you go. This will create a simpler, more polished drawing. Shade and highlight the cat's stripes to echo the light source reflected in its eyes. Keep things as consistent as possible.

3 The pattern on the dress is subtle, but evocative of the medieval era. Make sure the pattern follows the curves of the figure or else it will appear too flat. Add highlights and shadows to make the figures appear 3-D. Give her a flustered, youthful expression by adding a rosy color to her cheeks.

Lich King

Lich comes from the Old English word for corpse. Crowned by fiery magic, the Lich King controls an army of death. This character has become a powerful undead wizard in fantasy fiction. Liches and their endless armies of skeletons play on our fears of death and corruption and the horror of the animated dead overwhelming the world of the living. It's a powerful idea for a fantasy villain, one that works on many levels.

1 Draw the Lich King floating above the ground to exaggerate his magical powers. Use the standard proportions for the figure. The hands are large and claw-like to imitate the appearance of skeleton hands.

2 Add details on the figure such as tattered wrappings and a torn cape. The wrappings are meant to refer to the mummification process of the ancient Egyptians, indicating that this monster is a primeval evil. The swirl of skulls and bones reinforces the control of the undead power of the Lich.

He is crowned with magic floating crystals and his head is aflame with power. Nothing says "powerful bad guy" like a flaming skull.

3 Make the flames a light color so they appear less solid. Smooth shading on the dust makes it look soft and powdery. Don't forget the shadows of the skull and arms on the cape. The skin should be a pale, unhealthy color. The bandages are stained and dingy, yellowed with age and decay. The eyes are glowing with supernatural power. Very scary.

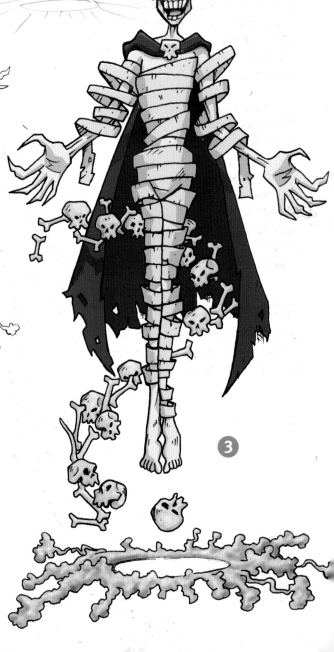

skeleton Warrior

The Skeleton Warrior is a classic creature of fantasy fiction and mythology. Undead warriors are horrifying opponents because they beg the question, "How do you kill something that is already dead?" Skeleton Warriors are mindless creatures, shambling across the landscape in a relent-less mission to destroy the living.

1 The Skeleton Warrior is a very complex and daunting subject to draw. You can't fake your knowledge of anatomy in a drawing. Block in the pose and begin indicating major anatomical details such as the rib cage and pelvis.

2 Don't be afraid to use anatomical reference books or go out and buy a plastic toy skeleton to look at. Line thickness really helps describe the weight and structure of the bones. After carefully inking the drawing, erase the pencil lines and prepare for coloring.

3 Softly shaded bones appear more 3-D. The bones should be yellowed and weathered. The shield and sword are dented, dinged and falling apart. Is that blood or rust on that sword?

Dragon

Dragons have found their way into the mythology of many cultures. Perhaps ancient storytellers sought to explain the remains of dinosaurs or maybe they struggled with the basic personifications of good and evil and settled on the serpentine creatures we have come to know as Dragons.

The Dragon is a symbol of evil and greed, and often defends priceless treasures. Defeating a Dragon is the ultimate challenge of any fantasy warrior. Most Dragons are asleep, hidden away under mountains, waiting to be awakened to defend their treasures. Others are active forces of destruction, spreading pestilence and corruption. In the world of the Kingdoms, almost all the Dragons were hunted and it is impossible to say how many survive.

1 Block in the basic pose with lines and circles. Keep things loose and rough. More detailed elements such as the hands and tail can be fleshed out later. For now capture the basic structure.

2 Flesh out the body and add details. The wings are large and bat-like and the leathery skin is webbed between long, bony fingers. The hook on top of the wing corresponds to the wing's "thumb." Block in large defensive belly scales and wrap them around the bottom of the body. They make excellent fireproof shields for experienced dragon slayers.

3 Draw through as you add details. The spikes on the forearms and lower legs relate to the spikes down the spine and on the wing. These spikes help propel the dragon through difficult underground passages and are nasty weapons in a fight. Place the wings just above the shoulders. Dragon cousins, known as Wyverns, have massive wings instead of forearms.

Ancient Guardians

Dragons were not always symbols of evil. Most dragon legends see the Dragon as a guardian creature, more of a watchdog than a mad dog. Asian Dragons are even more benign, floating on clouds and dispensing wisdom and good fortune. Dragons are magical creatures of immense power, intelligence and magic. They are the ultimate challenge and the guardians of the ancient treasures and knowledge.

4 Carefully ink the image, varying line thickness to help define the form and make parts of the image appear closer. When the ink is dry, erase your initial pencil lines.

5 Make your Dragon any color—gold, red, blue, green. I chose green because it seems more natural for a lizard. The wings are textured to appear veined and leathery. The body is covered in small scales. Because dragons are so huge, each scale might be the size of a saucer or plate. Shade the figure to make it look 3-D. Light rakes across a surface creating predictable areas of highlight and shadow. Pick a light source and stick with it.

Dark Elf

Dark Elves are subterranean creatures who long ago set out on a different path from their forest-dwelling cousins. They were corrupted by evil forces and started to prepare the world for the awakening of the forgotten gods. Dark Elves seek to bring about a time of darkness and eternal twilight to the world, where the forgotten gods can rise again and claim what was lost to them. They are skilled mages and excellent fighters and if they ever succeed the world of the Kingdoms is doomed.

1 Quickly sketch the pose. The left hand is extended toward the viewer and seems larger due to foreshortening. Curl and twist the edges of the cape and make the hair wild.

2 Add details to the clothing, anatomy, and weapon to help define the look of the Elf. Draw striped leggings, curled edges on the cape, a crooked sword, laced-up clothing and the spider broach. The face is long and fox-like, less human than the Forest Elves.

3 The stunning blue skin sets the Dark Elves apart from their woodland relations and humans. Corrupted by the dark powers, Dark Elves are more magical than mortal. The colors I chose were muted and darker versions instead of bright, colorful blues, greens and purples. The clothing still has a spiral pattern, echoing the cape curls, but also referring to the spirals found on Elves and magic-using humans.

Satyr

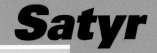

Satyrs are nomadic creatures who plunder towns and caravans. They are small, but powerful warriors and can outrun most horses. In mythology Satyrs were wise teachers, keepers of ancient knowledge. This Satyr is a small lion-humanoid creature from the plains of Estavia. He has spirals tattooed on his head and holds a bone carved with mystic spirals. He is likely a chief or a shaman of a Satyr tribe.

1 Even though the figure is not human you should think of the forms as real structures in a 3-D space. Start drawing the figure with basic forms to simplify complex images. Keep your pencil lines light; you have to erase them later.

2 Add an odd assortment of physical features such as toe-walking (digitigrade) legs, a lion-like tail, and an odd-toed foot (Perissodactyla). The earrings are a playful addition making this creature less wild and more mainstream than most monsters.

3 The Satyr is small, maybe 3 to 4 feet (92cm to 122cm) tall, but it has a powerful form and strong, stable legs. This Satyr appears 3-D thanks to consistent light source and thoughtfully placed areas of highlight and shadow.

Fey

The other world of Faery is a shadowy realm of forests and babbling brooks. It is tucked just out of reach of our world and connects to the land of the dead in places. Fey are magical creatures that flit between worlds. More mischievous than malicious, Fey are small, playful and love sweets. But don't get them angry or they will use their reality warping magic, or glamour, to really mess you up. This little one looks a bit upset that we've seen him.

1 Sketch in the structure using childlike proportions. Fey have two sets of wings and insect-like antenna. The wings can be transparent like an insect or colorful like a butterfly. It isn't known why Fey appear like insects; it could be part of their shy nature to hide as bugs or an effect of their reality warping magic.

2 Look at real insect wings to make sure the details are right. Dragonfly wings make good models for Fey wings. Keep the ink lines simple and expressive with thick and thin lines describing form and mass. Carefully erase the initial pencil lines and fill in the black stripes. Your own Fey could have spirals, polka dots, or even patterns on its clothes—it's up to you.

3 Carefully color the wings to be transparent and show a lighter version of the color through them. The blue skin is more alien and bug-like than human.

Pixie

Faery folk are notoriously child-like and kind of cute. They are even less human than the Fey. Somehow, the strange leaf-like wings let them fly. No two Pixies appear the same—some have one antenna and others have four. Some have small wings while others have huge wings. They are known for their mischief and ill-timed funny noises.

1 The Pixie is not an overly complex character to draw. You can invent your own attributes because all Pixies look a little different from one another. This one uses super deformed proportions and is very cartoony.

2 Even though the Pixie doesn't look very realistic, you still want it to appear 3-D. Use thick and thin ink lines to describe its form. This helps us accept the reality of the Pixie despite knowing there is no such creature. Drawing fantastic creatures in a realistic way is what fantasy is all about. The teeth and open mouth are considered very child-like and ill mannered in manga and anime.

3 Color your Pixie simply, using any color. I chose earth tones, but it could easily be hot pink or baby blue. Remember to make the creature look rounded with carefully placed highlights and shadows.

Kappa

Kappa originated in Japanese mythology and are a bizarre amphibious combination of turtle, frog, monkey, otter, lizard and human. They are short and childlike in appearance. They are incredibly strong and have a taste for blood. Kappa have been known to drag people and animals to their deaths under the water. They must keep water from their pond in the bowl-like depression on their heads or they will lose all power and be frozen on the spot. One trick is to bow to them, being creatures of impeccable manners, they will be compelled to bow back and spill the water.

1 Block in the basics keeping in mind the squat, turtle-like anatomy and strange, inhuman features, such as the domed head, giant ears, oversized webbed feet and hands, and thick tail. The shapes that make up the drawing are simple geometric forms. Keep your figure loose at this stage, drawing lightly with your pencil.

2 Add the details. Carefully taper the linework from thick to thin lines to describe the form and mass of the monster. Draw water sloshing around in the recess on the head. Also create the markings on the skin. The webbed hands have three tiny suction cups so the Kappa can grasp his prey and drag it underwater.

3 Color the Kappa green with speckles like a frog. Shade and highlight the body to make it appear rounded and 3-D. Its eyes glow with intensity and the water seems to imply that the Kappa is moving forward to strike.

Merfolk

*T*raditional sea shanties have long sung about the mermaid, half human, half fish women who lure sailors too close to rocks with their singing and drag them to their doom. These stories are only half right, Merfolk do indeed live in the sea, but they are less human and less fishlike than the sailors would care to imagine. Merfolk are somewhat humanoid with the lower half of a sea horse. Organized and highly cultured, they rule vast undersea kingdoms and try to have as little to do with humans as possible.

1 Block in the figure. The lower half should be a single tube, curled around at the base. The upper torso is similar to a human form, but add fins and gills.

2 Carefully add the details and define the drawing with ink. Erase the pencil lines. Merfolk have distinctive patterning on their lower halves. Each one is different. Fins allow Merfolk to propel through water and turn quickly. Merfolk also have some odd undersea adaptations such as large black eyes, neck gills, claws and fangs for tearing apart prey and a reinforced rib cage to withstand the changes in undersea pressure. Add bubbles reinforce the undersea look.

3 The green skin is more leathery than scaled. Take care to define the areas of light and shadow to reveal form. Add streaks of light on top of the creature to make it appear like light is filtering down through the waves and ripples of the ocean. These stripes of light give you yet another chance to show the 3-D form of the Merfolk.

goblyn Warrior

Goblyns are a diminutive species thought to be a degenerate form of Elf or Human. They are fast, wily, and full of berserker fury. In recent years they have emerged from underground cities to take over large areas of foothills and mountains with their surprisingly large numbers. Fortunately they are relatively weak when alone. Goblyns succeed through their cunning, wickedness and sheer numbers. This Goblin Warrior is only 4 feet (122cm) tall and has a weapon that is almost as heavy as he is. He is in a full-out assault and seems to have little regard for the possible consequences.

1 Block in the forms, giving the Goblyn childlike proportions. Keep the image simple for now, slowly adding details to the geometric forms. Remember that the details should appear 3-D. Think cones instead of triangles for the spikes on the feet.

2 Describe the form with ink lines. Don't simply trace the pencil lines, vary the line thickness. Little touches such as the goblyn-faced belt and spiked boots add a lot to the character and personality of the drawing. Carefully remove all the pencil lines.

3 Carefully render the image. Think about it; don't just color it in like a coloring book page. Carefully render the image keeping in mind the way that light falls over a form and how overlapping forms cast shadows. Pay attention to the 3-D form of the figure as well as the patterns and textures that will add a sense of realism to the drawing.

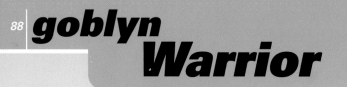

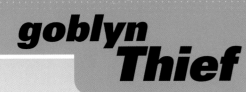

goblyn Thief

Goblyns don't have a very sophisticated sense of how to build things. They like to take things that are already made—it's a lot easier that way. Goblyn Thieves are small, silent and intelligent opponents who can get past any traps or guards with an almost diabolical ease. As you can tell from this drawing, they have a lot of fun while they're doing it.

1 Block in the basic structure using child-like proportions. You can make the head a little bigger and the feet and hands a bit lankier as well. The ears point back and less out to the side than on an Elf.

2 Add details such as the wild expression and the ornate heavy sword to give the drawing personality. Carefully shade the stripes on the leg with ink lines to help describe the rounded form. Add highlights to the leg stripes and eyes to establish the light source for the drawing. Use thick and thin lines to describe the form and carefully erase the underlying pencil.

3 Shade the figure with care, always being aware of the light source in the upper left-hand side. Use highlights and shadows to develop the forms, and place cast shadows such as the area under the head and under the far leg help to help reinforce the structure of the figure.

elfin Sorceress

Elves originally came from the land of Faery and their link to the "other-world" gives them remarkable power over the nature of this reality. Elfin magic uses the basic forces of the natural world to manipulate reality. This Elf is using the elemental magic of the wind to kick up a wall of leaves and debris. The wall can be used to defend against attacks or knock down an opponent.

1 Block in the basic pose making her 8 heads high. This makes the Elf appear tall, powerful and somehow more perfect than a mere human. Sketch in details such as the cape and winged gloves, shoulders and boots. The oversized wing shapes echo the ears of the Elf.

2 Add many complex elements to the basic structure. Detail the sharp spiral pattern in the cape and the armor pieces. It's interesting to note that the leaves are moving in a similar spiral pattern, perhaps revealing the nature of the magic that is manipulating them. Pay attention to little details such as the stitching on the boots and the varied shapes of the leaves. The details give the drawing life and character.

3 The pants pattern mirrors the colorful autumnal leaves. This image is carefully shaded with a distinct light source. The body stands out from the back of the cape because it is lighter than the shading in the cape. Carefully render areas of shadow and highlight for a strong 3-D effect. Don't be content to just color in your drawings—make them live and breathe.

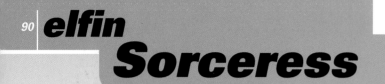

elfin Warrior
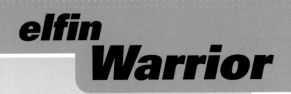

Elfin Warriors are staunch defenders of their realm. They are mystical fighters with supernatural abilities to disappear into the forest and surprise their enemies by suddenly reappearing and attacking.

1 Quickly block in the structure using geometric forms and keeping a strong sense of movement and action in the pose. His armor and weapon are wildly oversized for his proportions, but they make him appear larger than life and even more powerful.

2 Flesh out the figure. Add the spiral carvings on the armor to connect him to the Elfin Sorceress. Make sure the image is rounded and in proportion before you add the details. It's easy to lose sight of the basic drawing when you are adding details. Erase the pencil lines and make sure the ink helps describe the form and isn't scribbled. The lines on the sword blade or the hair on the helmet should reinforce the shape and structure of the surface.

3 The hair on the helmet is based upon the ancient Greek hoplites and the Roman centurion. Raise and detail the spirals on the armor with highlights and shadows to make them appear rounded. Shade the spiral carving on the sword to make it appear recessed in the metal. Use this last stage as an opportunity to really make the forms appear rounded and 3-D.

Demon

Demons come in all shapes and sizes, but because they are creatures of chaos, the less human they appear the better. This is one ugly Demon. Making him over 30 feet (10m) tall makes him even uglier. His shape is just a glorified blob with huge teeth and bat-wing ears. In true manga and anime spirit the wings can probably allow the Demon to fly.

1 Draw simple shapes. His body is just a big egg shape with a few limbs and a tail tacked onto it. Use precise lines so you have fewer pencil lines to erase later.

2 Outline the body shapes in ink, adding details such as the patterned skin, uneven claws and teeth, slimy spit and smoke rising from the eyes. Erase the pencil lines and make sure the ink helps describe the form and doesn't flatten the drawing.

3 Hot, searing smoke rises out of the eyes and diseased green drool drips out of the mouth. Carefully render shadows and soft highlights on the surface of the figure for added realism, even though his proportions and details are totally unbelievable.

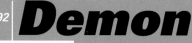

Drakkin
warrior

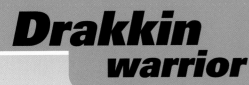

The Drakkins are a mysterious race of humanoid Dragons once found all over the southern lands; they were defeated by the Elves ages ago and slipped into hiding far across the Southern Sea, beyond the Vistiran Islands. Every now and again a Drakkin shows up in the Kingdoms, usually on a mission to find some lost treasure or defeat an ancient evil. Humans are afraid of them, Elves hate them and Dwarves tolerate them (as long as there is gold to be had).

1 Draw an active and heroic pose. The wings and tail create a strong area of visual impact. The sword is slightly tilted on a diagonal for a more dynamic pose. If the sword were straight up and down the action would be less intense. Dynamic diagonals create more exciting visuals. Keep the structural lines visible as you add the details. Drawing through keeps everything where it should be and avoids distortion.

2 Carefully outline the pencils with ink lines of varying thickness. The thicker lines come forward. The wings are meant to appear as if they are wrapped around the figure and closer to us. The tail is thinner and appears further away. Erase the pencils after the details are done and the ink is dry.

3 Shade the Drakkin carefully to reinforce its 3-D nature. Highlight the metal. The shadows of the bracelets help describe the rounded forms of the arms. Think about the structure as you render your image. Never simply "color it in."

Blobby

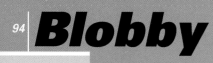

Blobbies are strange liquefied creatures who live in the shadows of the underworld and eat metal by dissolving it. Blobbies are very dangerous for people in armor and can reduce a sword to dust in a few seconds. They like to hang out on dungeon ceilings and then drip down on unsuspecting knights, dissolving their armor so they can fill their tummies. The only sure way to kill a Blobby is to destroy it with fire.

1 This looks simple, but don't forget that the forms of the object must be 3-D. Even this simple egg shape should appear to exist in physical space or else it will look flat and fake.

2 Thick and thin lines give a sense of form and mass to the Blobby. Details such as drips on the surface of the Blobby, bubbles in the liquid and reflections in the puddles add more realism to this fairly simple image.

3 Strong highlights and shadows make the Blobby appear more reflective and wet. Remember to think of the Blobby as a rounded form with a main light source. Ignoring the light source and coloring in things flat will ruin the suspension of disbelief and make this impossible creature seem even more improbable.

tentacled Horror

The Tentacled Horror is a monstrous incarnation of the forgotten gods of ages past. It is alien and evil, existing only to destroy and kill and consume. Followers of the forgotten gods such as Dark Elves and insane wizards can only summon this creature, not control it. Once summoned, the Tentacled Horror will attack populated areas, destroying, killing, and feasting upon anything that stands in its way. The Tentacled Horror is over 20 feet (6m) long and can slither as fast as a galloping horse. The eight tentacles grab its prey and drag it to its gaping maw. Powerful claws fend off any opposition and its leathery hide can withstand the sharpest blade.

1 It may not be human, but that doesn't mean you shouldn't plan out your drawing. Draw the serpentine body as a tube along with the tentacles and claws. The closest claw appears bigger because of foreshortening.

2 Draw ink lines over the pencil to reinforce the form. Use the lines to define the surface of the form and reveal the texture of the creature. The many lines at the base of the tentacles show the muscles at work.

3 Precisely shade and highlight the creature to create a 3-D look. The mouth looks like it can be extended to bite and tear its prey. Despite the fact that the monster is inhuman, realistic attention to shading creates a very convincing image no matter how bizarre it is.

giant Rat

Oversized animals are commonly encountered in fantasy stories. Thought to be the result of some magical accident or experiment, Giant Rats are 3 to 6 feet (92cm to 183cm) long and some have been trained as beasts of burden by Goblin tribes. The Giant Rat is a clever opponent and relentless in its search for food.

1 Block in the structure as usual using circles, tubes and ovals. This creature is rising up in alarm, turning and looking to defend itself. Keep things loose, but remember to treat each anatomical detail separately.

2 Ink the image and erase the underlying pencil lines. Make the fur appear rough and unkempt. Draw an angry and terrifying face. Creating small details such as the drool dripping out of the mouth and chunks taken out of the ear make the Giant Rat look real.

3 Shade and color the creature with the light source being from the top. The eyes glow red with rage or maybe it's just how he sees so well in the dark. Remember to highlight areas of fur that rise up from the surface.

dire Wolf

The real Dire Wolf was larger than average (5 feet [153cm] long and 110 lbs. [50kg]) and actually lived 16,000 years ago. In the world of the Kingdoms, the Dire Wolf is a monstrous creature standing 4 feet (122cm) high at the shoulder and over 8 feet (244cm) long weighing in over 200 pounds (91kg) of muscle. The Dire Wolf is a terrifying hunter of the northern planes, who was unnaturally mutated by an explosion of chaos magic. Some Northmen have domesticated Dire Wolves and use them in battle, but usually they are feared for their unpredictable nature. Dire Wolves are still rather rare creatures, often leading a pack of normal sized wolves with their strange intelligence.

1 Exaggerate the anatomy from that of a normal wolf. This wolf has only three claws and a terrifyingly large mouth and teeth. The mark of chaos has mutated them with horrifying results. Lightly block in the details with pencil as simple geometric shapes.

2 Ink the light and dark lines of fur in the direction that it grows. Never scribble in an area to show texture; make sure all your lines help describe something about the drawing.

3 The blue fur and glowing yellow eyes are the mark of chaos upon this beast. It looks dangerous and unnatural. The jaws are powerful enough to punch through plate mail armor. Use a consistent light source to show areas of highlight and shadow on the surface of the Wolf.

linear perspective
Basics

Linear perspective is an art technique that can make the flat surface of the picture appear to have depth. Manga artists can use it to draw backgrounds and objects that appear in the comic. There are three types of perspective that you need to know.

One-Point Perspective

In one-point perspective, parallel lines in your drawing appear to meet at one point on the horizon or eye-level line. All lines that recede in the image must converge at this vanishing point. The remaining lines (horizontal and vertical) are parallel to the edges of the panel or paper. Try looking down a road, sidewalk, or railway track. Notice how the lines seem to converge to a single point on the horizon and buildings, vehicles and objects lying parallel to the road also converge to this point. The vanishing point acts as a natural focal point because everything converges at that one spot.

Two-Point Perspective

This perspective allows for a more natural-looking, realistic image than you get with one-point perspective. Here lines converge on two vanishing points on the horizon line. Pretend you are looking at a box with one corner facing you. The horizontal lines on the right will appear to meet at one spot to the right on the horizon and all the lines on the left will appear to meet at a point to your left on the horizon. Only the horizon will appear as a true horizontal line. All others will be angled diagonally towards the vanishing points. Vertical lines remain at a 90-degree angle (straight up and down) to the horizon line. When you are drawing a scene, sometimes the vanishing points will fall outside the paper. That's OK. You can add extra paper to find the vanishing points and finish drawing your scene. If you create your vanishing points too close together, your image can appear distorted.

Three-Point Perspective

Three-point perspective produces very dramatic images. You use it when you are looking up at something, such as a building, or looking down into a scene. In this type of perspective, select the first two vanishing points the same as in two-point perspective and then add a third point either above or blow the horizon. All vertical lines will converge at the third point, making objects appear to get smaller the farther away they are from the viewer. If you are looking up, place the horizon line lower on the page and the third vanishing point above the horizon. If you are looking down, place the horizon higher in the picture plane and add the third point below the horizon.

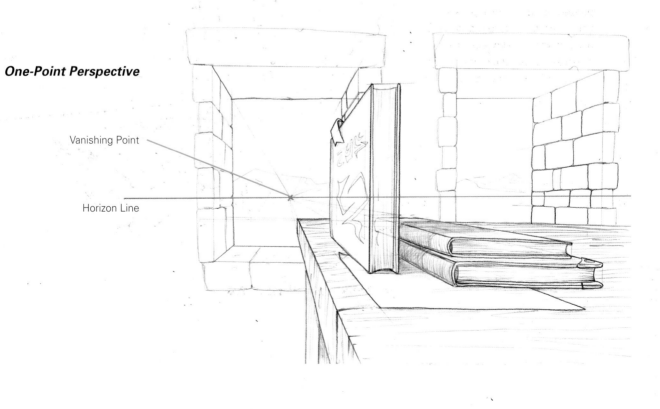

One-Point Perspective

Vanishing Point

Horizon Line

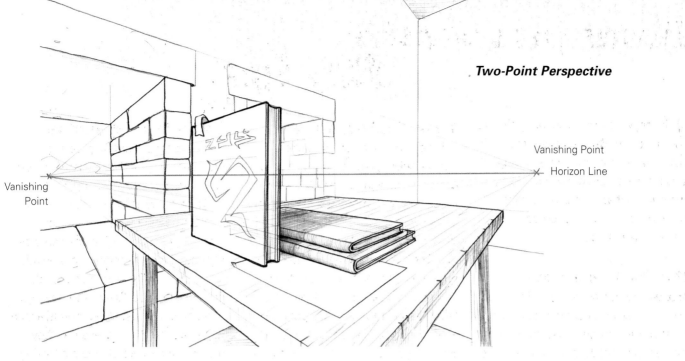

Two-Point Perspective

Vanishing Point

Horizon Line

Vanishing Point

Vanishing Point

Drawing Cylinders in Perspective

When you draw cylinders in perspective, their appearance depends on where they fall on the picture plane. Although we know that the bottom of a cylinder (like a mug or a quarterstaff) is flat, it will actually appear rounded as an ellipse or oval. When the cylinders are shown above the horizon we can see the bottom as it rises above the eye line.

To draw an ellipse, draw a square in perspective, then draw diagonal lines from corner to corner to find the center of the square. The ellipse can then be drawn as four careful curves that touch the sides of the square at the four points.

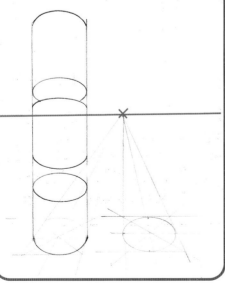

Vanishing Point

Vanishing Point

Horizon Line

Three-Point Perspective

Castle

Creating a convincing setting is just as important to a fantasy manga as drawing convincing characters. In a sense the setting becomes an additional character in the story, full of mystery and wonder. The castle seems to be a reasonable place to start.

1 Block in the horizon line and the two vanishing points. Use basic shapes drawn in perspective as the foundation for the castle structure.

2 Continue fleshing out the details of the buildings and sketch in some of the surrounding area such as the moat and the background mountains.

3 Clean up the initial lines as you develop the details of the buildings and the surroundings. With all the extra lines involved in perspective drawing it is often easier to trace the good copy onto a fresh sheet of paper. Try to be accurate and use a ruler if you need to. I chose not to use a ruler for this tracing because I wanted the walls to appear more organic and less perfect than ruled lines can create.

4 Much of what makes the image convincing is done at this stage. Color the sky, water, mountains and grass with the idea that things that are further away from you outside will appear lighter in color and duller than what is closer. This is because the nitrogen in the air reflects light and obscures what is further away from the viewer. The light source will cast shadows on the building. Remember to be consistent with the lighting. Details such as the stone on the walls will appear smaller and closer together when drawn on walls that are farther away.

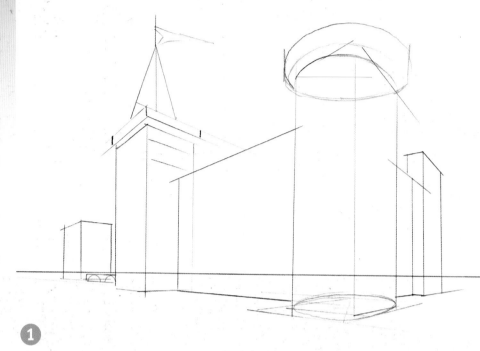

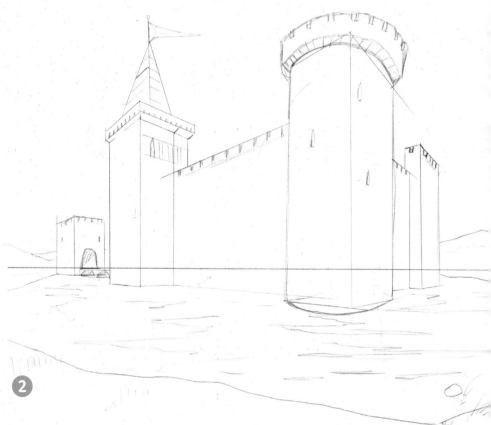

Perspective Tips

Things that are further away will:

- Appear smaller.
- Have less detail.
- Appear lighter and duller outside during the day.
- Appear darker and duller inside or at night.
- Be overlapped by objects that are closer to the viewer.
- Sit higher in the picture plane and closer to the horizon line.

③

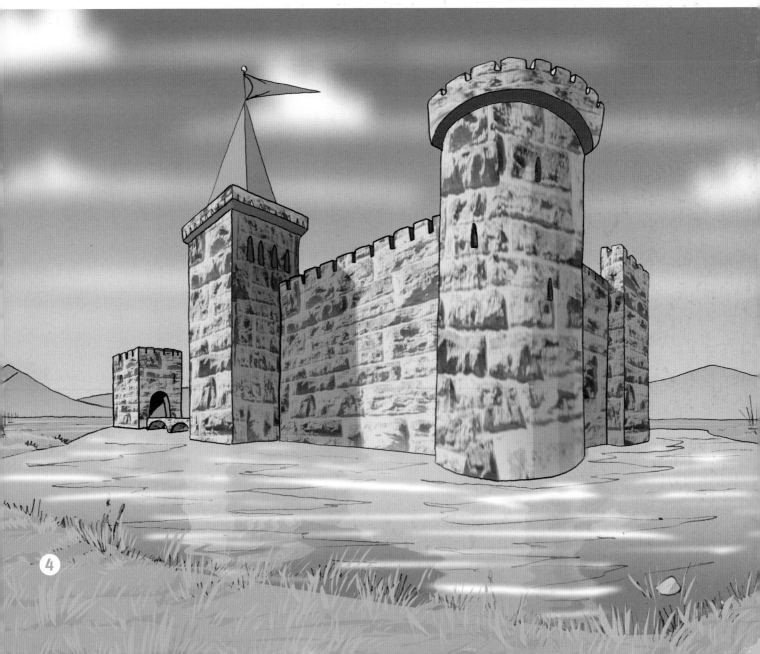

④

Tavern

This tavern sits on a busy riverbank in a fairly well developed urban area. Historical cities were often no larger than tens of thousands of people in medieval Europe. Fantasy cities can be as large as you like, but they would be very different places than the sprawling modern cities we are accustomed to today. The Tavern is a classic starting point for potboiler fantasy adventures. Heroes often meet in the tavern, start a fight and then set off on a rollicking adventure only to find themselves back at the tavern after it is all done.

1 Establish the horizon line and vanishing points and then draw the basic shapes of the tavern in perspective. Use a ruler to ensure greater accuracy.

2 Use photo references where you can to add convincing architectural details such as windows and doors, rooftops and cobblestones. These details make the tavern look more like a building and less like a collection of tubes, cubes and prisms.

3 Clean up the lines on your drawing, then add a background and flesh out the surrounding area as you go. Make sure the shingles and stones are in proper perspective. The angle of the roof should be a good guide for the angle of the shingles.

4 The picture is a nighttime image so the standard lighting rules won't apply, which makes shading and coloring a little tricky. You should still choose a main light source. This could be the light from other buildings or from a torch or lamp in the picture. Other details such as reflections in the water and highlights on the surface of the water add realism and depth to the image. Add the water reflections digitally by copying the existing image of the building, reversing and turning it upside down. The image was then distorted to achieve a ripple effect. Finally the image was lightened to illustrate how reflections appear lighter than the original.

1

2

3

Fantasy Tavern Activities

- Drink grog.
- Pick a fight with an Ogre.
- Meet up with other adventurers.
- Drink more grog.
- Play games of chance (dice) and skill (darts).
- Find out information regarding the latest adventures.
- Listen to legendary stories and histories.
- Fall asleep in the corner.

4

subterranean Dungeon

The dungeon is a stereotypical setting in fantasy manga, but you can also apply its basic shape to other settings. With a little modification this could be the interior of a castle or the ruins of an abbey. Let's create a dungeon using two-point perspective.

1 Draw the horizon line and two vanishing points. Then add the two points above the horizon line. These points are the angle points for the stairs to rise toward and where they will converge. Block in the vertical lines and draw the main walls of the room. Establish the angle ramps of the stairs. I generally draw the stairs at a rough 45-degree angle. Set up space for the windows and doors even at this early stage.

2 Lightly draw in the details, such as the stonework around the doors and the individual stairs. Use a ruler to make sure your lines are accurate and easy to erase. Rest your hand on a piece of paper or another ruler to avoid smudging the pencil lines. Draw big vaults or arches supporting the weight of the ceiling. Shape the doors and windows to come to a point at the top. This is in the 12th- to 16th-century gothic style.

3 Clean up the extra pencil lines and finish the details in ink. You can retrace your image if there are too many lines. The torches will be the only light sources in this drawing. Things are about to get very gloomy.

4 Try to respect the light sources as you apply areas of light and dark in your shading. The walls are stained and uneven and the place seems pretty damp and moldy. The floor tiles are uneven and randomly placed. The larger tiles are closer to the viewer and the far tiles appear smaller and more cramped. This creates a sense of depth and space.

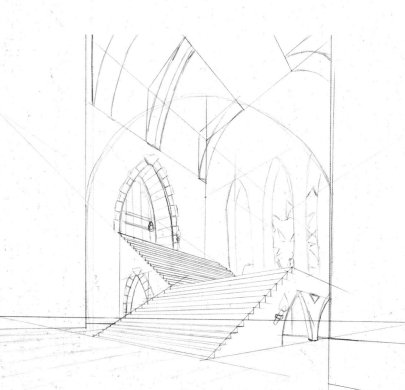

1

2

Useful Dungeons

The dungeon was originally the lower part of the central keep or tower of a castle. The bottom part of the tower was built without windows to ensure that it was strong enough. This became a safe hiding spot during a siege and a convenient prison. There were many prisoners to be had in the middle ages. Living knights were worth much more than dead knights because of the handsome ransoms that they could fetch. Knights were skilled professionals and rare amongst the general population, so it made sense that instead of killing captured knights, they should be held hostage until their family or king could buy their release.

3

4

elfin tree Shrine

Elves are not immediately known for their wonderful architecture. They are creatures in tune with nature and spend most of their time in the natural world, not inside a building. This tree shrine is a sacred site built high up in the canopy of the rainforest.

1 Establish the basic location using uneven tube forms for the branches and geometric forms for the building. Roughly indicate the bridges and stairs. Place the horizon line high in the picture plane so you know that you are looking down at the shrine from a higher branch.

2 Block in the details including the stairs, the rooftops, branch texture, moss and the suspension bridges that connect the treetops. Keep the details in proper perspective and avoid too many construction lines as they will be difficult to remove later.

3 Wrap lines around the tree branches to help reinforce the direction of the cylinders that make up the tree form. These marks describe the shape of the tree. Don't just fill in the area with random scribbles. Resolve the additional architectural details such as the scale-like shingles, the ropes and posts surrounding the platform, and the details of the suspension bridges. The shrine seems to have a few levitating stones in the building. These crystals may be a source of power or might be helping to channel the power of nature back into the trees so they can stay healthy.

4 The warm colors of the shrine contrast with the green gloom of the forest at night. The canopy of leaves is so thick in this ancient rainforest that a dark, cavelike atmosphere is created and most of the sunlight is stopped before it enters this area. The central lantern and glowing crystals of the shrine are its light source. Shade the tree trunks and the building to reveal the light source.

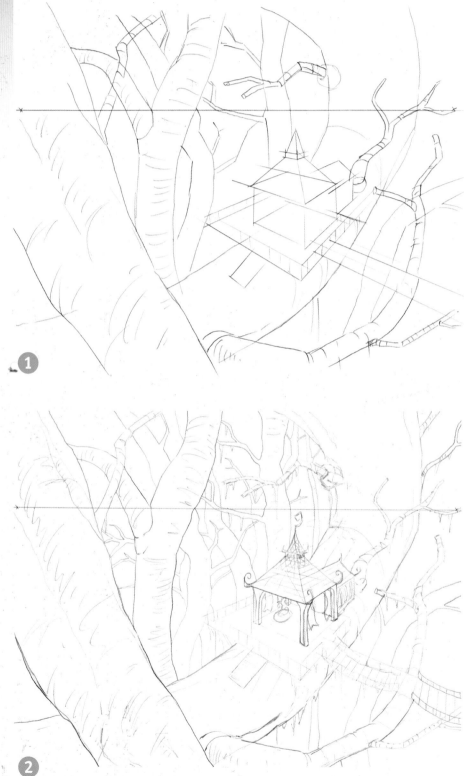

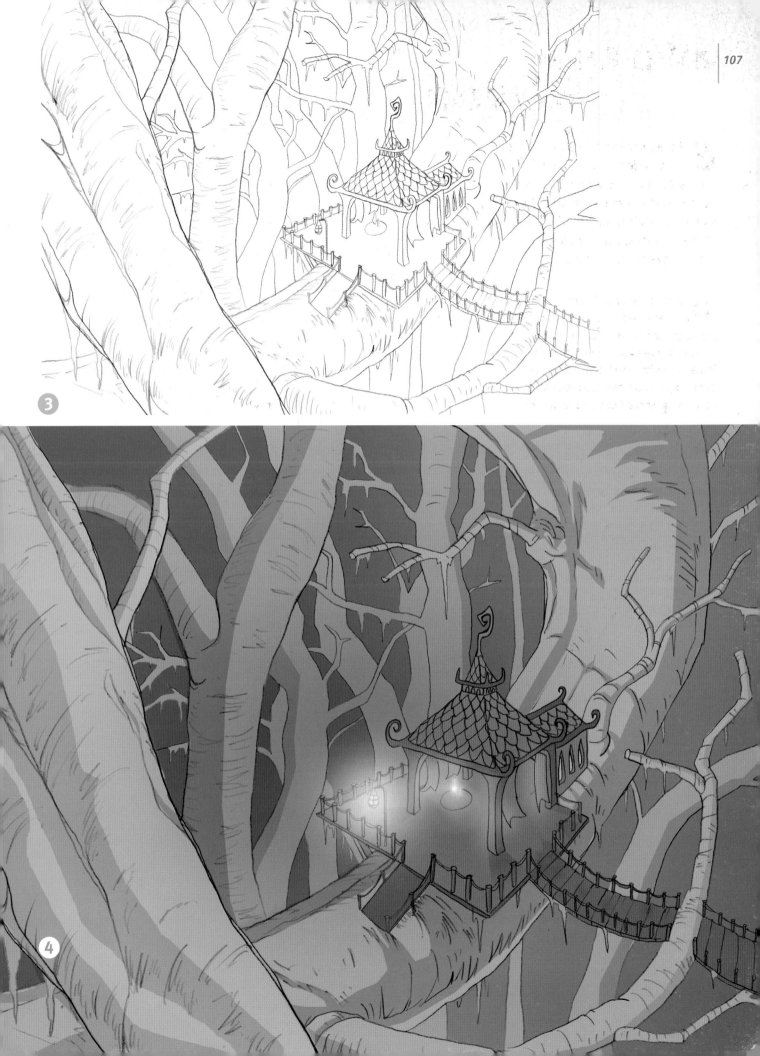

donkey Cart

Moving objects around from place to place requires a bit of brute force and ingenuity.

1 Block in the basic shapes of the donkey and the cart keeping in mind the rules of perspective. I usually draw in the surfaces of the objects that will cover the ground before I start drawing the subject. This allows me to plan where the image should go and create a sense of depth in the picture.

2 Carefully draw the details, making sure they describe the form of the subject and are not randomly doodled. The lines describing the mane, for example, should be drawn in the direction of hair growth.

3 Color and shade your image using a consistent light source. The donkey and cart may not move fast, but they transport items cheaply and efficiently. Donkeys are also really cute.

king's Ransom

*T*reasure chests and the treasure they hold are the products of legends and are usually the reason the heroes are out there bashing the monsters and lurking in dark ruins.

1 The treasure chest is just a box, but the lid is sort of an unusual shape. Draw the side of the lid first and extend the lines across making them consistent with the box. You can block in the perspective guidelines, or you could use rough guidelines and still make the image look convincing.

2 Look at all that treasure! Carefully draw and detail the individual items such as the sword and the chalice. Bring them to this level of finish before you apply the colors and shading. It doesn't make sense to draw every single coin in the chest so suggest the coins on the piles. Remember, the viewer's imagination will finish off the details of the drawing.

3 Pay attention to detail so you can create a more realistic image. Place the wood grain in proper perspective and highlight and shade the metal. Color and shade the treasure so it appears highly polished and shiny.

Airship

Sometimes the heroes have to get from place to place quickly. Other times the villain has a vehicle that lets them escape capture yet again. The flying machine may seem out of place in a fantasy setting, but manga, anime and video games from Japan use a lot of them. Inspired by the drawings of Leonardo da Vinci, this airship is powered by powerful magic crystals that act as engines, providing the energy required to lift and propel the wood, metal and canvas craft. A powerful wizard who gathered rare "lift crystals" from around the world built this vehicle and now seeks to build an entire fleet of flying machines.

① Quickly sketch in the basic shapes. This airship is really just a big barrel with wings. The odd curved extension on the front of it could be a docking attachment or part of a winch used to lift heavy objects.

② Clean up the lines and make the structure appear more crisp. Draw in the details such as the windscreen ironworks, the exhaust vents in the back, the sheets of bent wood and the bolts holding the metal together.

③ Ink and erase the pencil lines or trace the image onto another piece of paper. The key is that even though the object seems complex, it is really only made out of simple geometric shapes. Keep the 3-D nature of the vehicle in mind as you draw it.

3

4

4 Make the wood grain appear to follow the perspective lines and describe the surface of the vehicle, not work against it. Draw the crystals glowing with magical power. If you look carefully, a slight glow is firing out of the exhaust vents on the back of the engines. The glass windscreen should have highlights as it bulges out between the ornate ironwork. The canvas is softly shaded to appear smooth and less harsh than the wood or metal.

steampunk Mecha

Manga, anime and video games just can't resist the allure of the giant robot. It's also very fun to imagine Mecha that don't use high-tech parts, but are built as steam-powered technology. In the land of the Kingdoms, the Dwarves are building all kinds of vehicles and machines using steam-powered engines and are leading the great steam-tech revolution. Steam power requires super-heating large tanks of water and then using the steam to power turbines and engines. This requires a powerful furnace and water tanks. It would be hot and cramped inside one of these vehicles, but it would make an effective weapon. This Mecha would stand about 12 feet (4m) tall.

1 Block in simple forms. Even though you may not understand exactly how a steam-powered walking tank would be put together, that shouldn't stop you from drawing something that looks cool. The water tank on the back is a simple cylinder and the repeating crossbows mounted on the front are basic rectangular prisms.

2 Helmet visors of the later middle ages were the inspiration for the front ramming plate. The feet are similar to three-toed rhino feet, spreading a great deal of weight efficiently and allowing the vehicle to run at great speed. Other elements are refined to appear more chunky and 3-D. Notice the crossbow bolts affixed to boards; they act like clips for the repeating cross-bows and can be replaced when they are empty.

3 Ink the image and erase the underlying pencilwork. Make sure the armor plating details appear to wrap around the vehicle and help describe the surface. Adding small details such as wooden strips, observation vents and big and small rivets really make the drawing appear convincing. The cockpit is just under the visor, which has hinges and can rise up allowing the rider to jump in and out of the mecha. The furnace is the blocky object in the back. The superheated steam travels through the metal tubes on the side and into the drive engine located just behind the cockpit. The engine drives the leg mechanisms located in the wooden tubes under the body of the Mecha.

4 That's a lot of armor to keep clean so indicate a lot of corrosion and rust. The banged-up metal surface is also a form of camouflage. Nothing says "attack me with everything you've got" than a big shiny metal robot strolling through the field of battle. Shade the Mecha with a strong sense of the light source. The metal would still show some highlight and reflection.

various Weapons

Bolt Gun

The bolt gun is a dangerous rare weapon the Dwarf Alchemist uses to penetrate even the heaviest metal armor. The gun uses extract of Dragon blood to drive the powerful bolt-firing mechanism.

1 Draw a simple gun. Make the elements recognizable, but still base them on straightforward geometric forms. I have drawn in quick guidelines with a ruler, which makes sure the elements "line up" and are not distorted.

2 Trace the image onto another sheet of paper. Your new drawing should clearly show the cogs and other mechanical elements that fire the bolts. The ammunition clip rises up into the barrel of the bolt gun and can hold up to ten bolts.

3 Shade and color the object. Maintain a consistent light source and draw areas of highlight and areas of shadow. The metal will also provide areas of reflection, which is why you should shade some parts softer than others.

Mace and Chain

The mace and chain is a difficult weapon to master. It is much more powerful than a standard mace because the chain provides more momentum to the strike, doing more damage.

1 You're really just drawing a tube and a ball attached by a chain. The chain isn't as complex as it looks. Just block in a tube to represent the chain, then draw the alternating links inside the tube making one thin, the other flat and so on. Try to keep the links roughly the same size.

2 Clean up the details to make the object more convincing. Make the rough wood of the handle a different texture than the metal tip bolted to the top of it. This also contrasts to the banged-up metal ball at the end of the chain.

3 The ball should have an area of shadow and a highlight. The rough wood of the handle appears even rougher when it is rendered to appear 3-D.

Sword

Real swords look nothing like this, but because it's fantasy you can have some fun creating monstrous weapons without having to worry about how heavy they would be or how impractical it would be to swing. Despite the odd appearance of this sword, there have been weapons in the world that were similar in theory to this.

1 Roughly block in the sword, building upon basic geometric forms. Try not to be too sketchy with your linework or it may be difficult to erase later.

2 Clean up the lines and try to get a real sense of the object existing in space. Remember that everything from the pommel to the handle to the blade has a thickness. Try not to make the object look flat.

3 Shading the object helps to reinforce its 3-D nature. You may want to use reference photos of real swords to help you with the shading. A trip to a local museum or a history book can be very helpful.

Warhammer

The warhammer has two heads mounted on a wooden handle. One side is a bashing hammer, useful against chainmail armor, and the other is a sharp pick, useful to pierce heavy armor.

1 Quickly block in the basic forms, roughly indicating the details as you go. Remember that the object shouldn't appear flat, so try drawing it at an angle.

2 Simplify the lines, but don't lose sight of the underlying structure. Some lines, such as the ones on the hammerhead, help describe the angle of the metal.

3 Shade and highlight the hammer so that it appears rounded and exists in physical space. Don't just color it in. Think about the 3-D form.

enchanted Artifacts

Enchanted Scarecrow

This enchanted object is a small guardian made of wood that springs to life when someone gets too close. It's not really the most dangerous opponent you will face, but it is effective for scaring off the curious. It doesn't really do much more than jump out and chase people who get too close.

1 Have fun blocking in the basic shapes of the creature. It's not alive or based on anything so it can look like whatever you wish. Try to have a sense of the object in space. Avoid showing it from the side or directly from the front. A slight angle places it into space, making it more realistic.

2 Ink the image and erase the rough lines. Lightly block in the wood grain, trying to make it wrap around the object (as texture) and not flatten it (as a pattern).

3 The scarecrow is shaded smoothly to help describe the rounded carved surface more effectively. The eyes glow with magical power. Run away! Run away!

Crystal Sword

Swords are made out of all kinds of curious and impractical materials in fantasy stories. Crystals seem to have a mystical allure to the fantasy genre and so it's only natural that all kinds of magic items would be made from them.

1 Block in the basic shapes of the sword at an angle. An object at an angle or tilted just away from the viewer is more interesting.

2 Clean up the basic linework, but let some of the drawing through remain visible. Crystal is a fairly transparent material and you will be able to see the structure through the sword.

3 Crystals are very reflective and will have many sparkling highlights. Try coloring the linework in blue to help the object and appear more crystalline.

Magic Scroll

The magic scroll can contain a royal proclamation, a secret treasure map or a spell of power that can only be read once.

1 The shape of the scroll is a simple tube, but the fact that it's a tube made from rolling up a piece of parchment makes it a bit challenging. It's easier to draw the tube first, then draw a spiral along the side of the tube to represent the rolled up paper. Draw the lines along in the same direction as the tube.

2 Clean up the linework and add details such as the leather bands that keep the scroll closed. Surface lines help reinforce the direction of the parchment, but too many can make it appear scratchy and rough. The edges look rough and torn, like the scroll has been in someone's back pocket too long.

3 The scroll is shaded as a simple tube, but look on the end—the rolled up paper requires some more complex observation and shading. Try rolling up a piece of scrap paper to see what happens in the shading.

Magic Wand

Magic is an unpredictable power in the universe. Human beings have a difficult time processing magic. Too much power coursing through their systems changes them and makes them unstable and evil. The solution to channeling this raw energy is to use an enchanted object that will bear the brunt of the power, allowing the Magician to cast complex and powerful spells without the danger of losing his mind. The magic wand is the extension of the Wizard, but it keeps the corrupting power safely away from the fragile human body.

1 The wand is more than just a stick; it's a symbol of power and energy. The floating crystal is suspended below the wooden spiral by a particularly powerful spell. If the wood tried to channel the magic power alone, it would break.

2 Indicate some spiral carvings on the body of the wand. As you have seen elsewhere in this book, spirals seem to be some kind of magic shorthand or symbol. Some wooden texture is also hinted at on the surface.

3 Shade the final image, keeping in mind that the wand is just a bent tube. The crystal pulses with power just waiting to launch a firebolt spell at an unsuspecting Ogre.

creating a
Fantasy Manga Panel

Manga is visual storytelling using a series of sequential images combined with words. The manga artist (manga-ka) must be able to draw almost anyone or anything acting in every possible way and must also connect these individual drawings into a coherent story. The process of creating manga remains the same whether it's a science-fiction story or an action adventure. The idea for the manga panel comes first. A script or rough thumbnail layout is then used to plan the story—thumbnails are small, rough drawings of the final manga pages. A script is written with a description of everything that happens or is said. A rough thumbnail layout allows the creator to visually plan the manga from beginning to end; it also indicates where dialogue will be added.

1 Draw a Rough Layout
Draw very loose images to use as guidelines and to get ideas for general composition and pacing. A strong layout early in the process helps communicate the story in a more visual manner.

Who's Who In Manga Making?

It takes a dedicated staff of artists to produce a manga. There is often a separate specialist for each of the following jobs:

- Writer, responsible for the story and dialogue.

- Penciller, who creates a visual representation of the story.

- Inker, who carefully draws over and enhances existing pencil lines.

- Letterer, who writes the dialogue in caption boxes and word balloons.

- Tone artist or colorist, who, depending on the budget and printing realities of the individual manga, shades and/or colors each panel.

Manga creators often maintain a unique vision or style and are more likely to do all of the jobs themselves, or in conjunction with their studio team of professional artists.

Tighten Up the Images

2 Once the page flows nicely and each panel works to logically develop the story, tighten the images. Draw lightly in pencil on good copy paper. Block in the lettering and word balloons.

Final Pencils

3 Carefully develop details using reference where it is needed. Shade or indicate with an x the areas that should be filled in with black ink. If you are lettering by hand, this is the stage to complete the letters and word balloons. Most comic book artists add word balloons and lettering at the end of the process to allow for a smoother development of the artwork. Keep the lettering neat and consistent. Make sure it is readable and remember to proofread your script or roughs before you start lettering to avoid spelling errors.

Inking

4 Different artists use different inking tools: some artists use dip pens, technical pens, felt-tip markers or brush and ink to apply ink over the existing pencils. Take your time with the ink because it doesn't erase. Correct any errors with white paint or correction fluid. Carefully erase pencil lines after the ink and paint have dried.

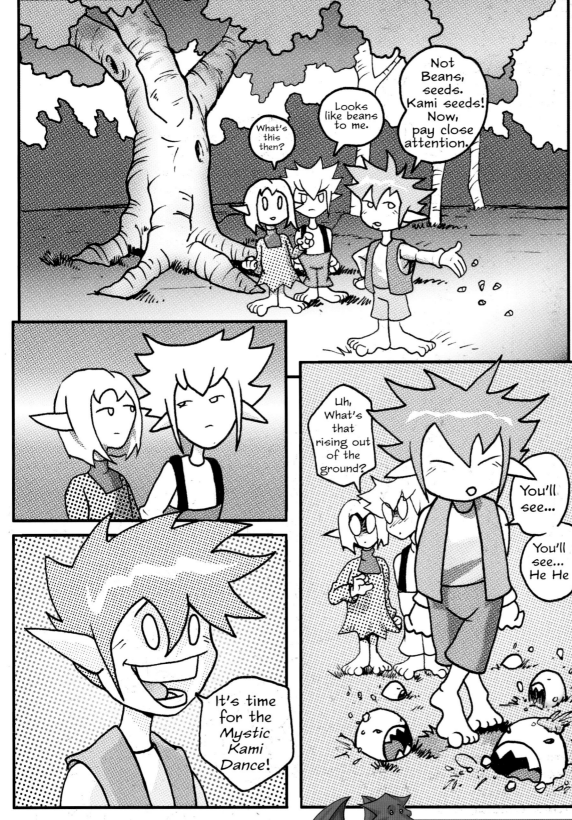

Tone or Coloring

5 This stage either applies to adding areas of valued tone or areas of color to the panels. Apply tone and/or color using traditional tools such as dry transfer screen tone, or colored pencil, paint, or marker. Most comics today are toned or colored with a computer.

Beautiful B&W

Traditional manga is usually done in black-and-white using dot tones to shade the panels. Some publications publish the first few pages of a manga in color, but it is expensive and rare. People usually discard most of their manga after they read it. Most manga readers have to wait until the animated version of the manga to see their favorite characters in color.

Storytelling

Manga stories are told quite simply by arranging panels on a page in a specific order. The reader fills in the transitions of time and space using their imagination. A manga artist really has two goals: 1) Controlling interest as the reader views the page. 2) Moving the reader through the panel. The best ways to control interest are through creative composition and panel transitions that make contrast such as a close up to a long shot or a light image to a dark image. The eye will be drawn to the larger figures and the dark areas of the page.

Moving the reader along through the panel is really the storytelling component of creating manga. The reader should linger on panels that propel the action of the story and skim along the other panels to gather details and information that help the action make sense. Readers stop to read text or look at very detailed illustrations. If you want to keep the action moving, keep it simple. Speed lines not only help indicate movement, they also help move the story.

Youthful characters have exaggerated eyes and simplified structure. Little touches such as the flowers on the hat and embroidery on the purse and skirt add character to the drawing, but can be a hassle to draw over and over again. Too much detail can be distracting; too little can appear too plain.

Establishing shots show details of the setting and the character's relationship to the setting. Keep a file of locations that can be used for reference when drawing settings. Fill a sketchbook or two with interesting drawings of trees, rocks, or buildings next time you are waiting for the bus.

This high over-the-shoulder shot draws the viewer into the scene and creates a sense of space and depth.

This close-up shot allows the reader to see more details and lets the artist really project strong emotions in facial expressions and body language.

Speed lines accentuate the sense of movement. The flowing hair and clothing also reinforces the direction and pace of the running. The goat girl is moving so fast that her hats flies off her head.

Creating a Simple Page

This page has a simple structure. There are five clearly indicated panels and they are all indicated clearly. The characters break the panel borders in two places. This creates a sense of immediacy and makes the character appear closer to the reader. Breaking the panel also draws attention to the subject.

ART 05-14

Moving the Readers Through Comic Pages

Plan your comic pages so the images and composition move the reader's eye across the page and through the story with minimal effort.

The reader usually meets profiles face on. The strong diagonals will lead the viewer down to the next panel.

The direction of the eyes leads the reader to the next panel.

The arm explodes from the panel for dynamic effect, but it also attracts the reader's eye and moves it into and across the panel. The point of the elbow moves the eye down to the last panel.

The wings of the dragon lead the eye into the scene and dramatically reveal what is chasing the girl.

Keep Your Pages Logical

Fantasy settings should have an internal logic about them that remains convincing despite the outrageous characters or events that are encountered. Small details such as the waterspouts, flower boxes, buckets and lanterns were all added after I looked at several photographs of British seaside towns. The fantasy world is a rich and diverse place that should be populated by a cast of thousands, each with his or her own quirks and personality. The setting should look lived in unless it's a crypt—but even then.

compare
Fantasy Manga Styles

Recently the popularity of manga has increased in the west and "American manga" had evolved as a result. American manga is a hybrid of western comics and Japanese manga. This genre has made many purists wince at the inconsistent mimicry of manga style and the use of panel layout, coloring, and lettering which is inconsistent with traditional manga. Manga is a work in progress. It is a style borrowed from Japan, where artists, in turn, had borrowed heavily from a wide variety of influences ranging from fine art printmaking to graphic design and comic book art of the early twentieth century. Each artist has his or her own unique style and approach. It's a good idea to develop your own style and not copy the style of another artist. There is plenty of room for personal interpretation.

Traditional Manga

This technique is much closer to the original manga published in Japan. There are generally fewer panels and the shapes and panel layout is often looser than what is found in Western comics. Some details and backgrounds are sacrificed because of the quick turnover and team approach of most projects. Action is dynamic and fluid. Speed lines represent movement and energy, but they also reflect blurred backgrounds and are one of manga's most enduring techniques. Areas of value are filled with dot tones. Traditional manga are rarely in color and coloring over the top of dot tone is considered crass and unsightly.

Traditional manga is read from right to left in Japan. Some Western manga-ka have adopted this convention to make their work appear more authentic. It is always a good idea to develop a feel for composition and flow in the direction that you naturally read. The manga can look rather forced or uncomfortable if you work against your natural sense of reading flow.

Hybrid Manga

Hybrid manga has dynamic action and
panel construction and vibrant color. Panel structure is
tighter and more controlled than traditional manga. Proportions and anatomy
are more often exaggerated and distorted. Fundamentals of Western comics, such as the influ-
ence of superhero elements and production quality using computer-coloring techniques, are used more often. Manga's
influence has touched even the most iconic titles in comics with entire comic book company universes getting a manga
makeover. Manga's influence is becoming more fully integrated into Western comics and the novelty is definitely wearing
off. Manga is now a much more respected and diverse art form today than it was a few years ago.

final words
on Fantasy

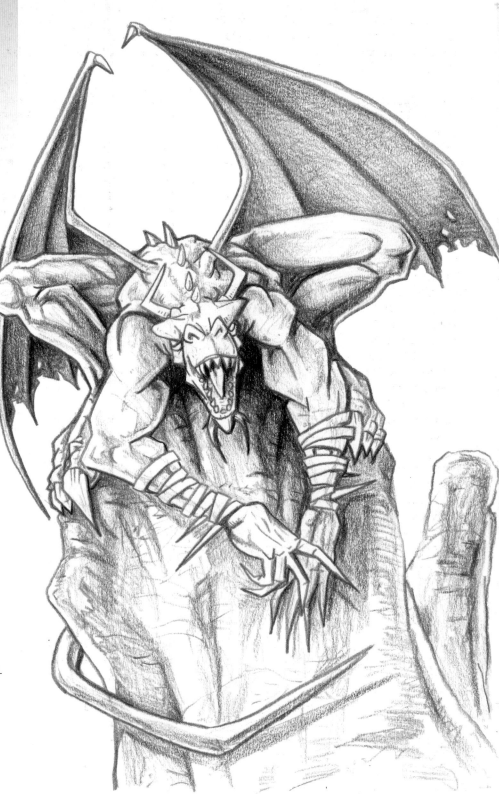

Fantasy manga can span many genres. You can make fantasy manga that is also a screwball comedy or a teen adventure story. Romance—even science fiction—is found in a manga fantasy story. Magical knights battling against star-trotting demons are totally acceptable. The only limits are your imagination and technical ability.

Fantasy manga frequently explores the connection from the modern world to a fantasy realm. C.S. Lewis explored this theme in his Narnia series. Also manga and anime creators such as Watase Yuu (*Fushigi Yuugi*) and Hajime Yadate and Shoji Kawamori (*The Vision of Escaflowne*) take normal characters out of their every-day world and plunge them into a fantasy realm, playing on the strange conflict of reality and the imagination. Connecting the world of the imagination with the world of the mundane allows an immediate connection and identification of what happens in the story. If the manga starts out in your home city, or a similar city in the real world, then you're more likely to suspend your disbelief and get sucked into the story. Dramatically, a stranger in a strange land also allows for pages of explanation of what the weirder elements of the world are and how they work. It makes more sense for an outsider to hear about how magic works, than a person who has lived in that environment all his life.

The ultimate goal in creating your own manga is to be original and have fun. Now that you know some of the archetypes go out there and change things around. Subvert expectations to create something truly innovative.

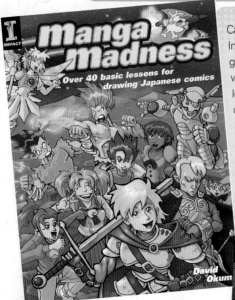
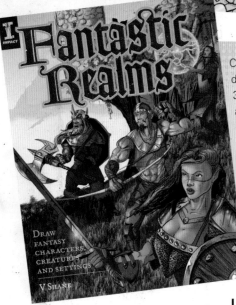